A Child's Garden of Verses
Suite for Piano and Reader:

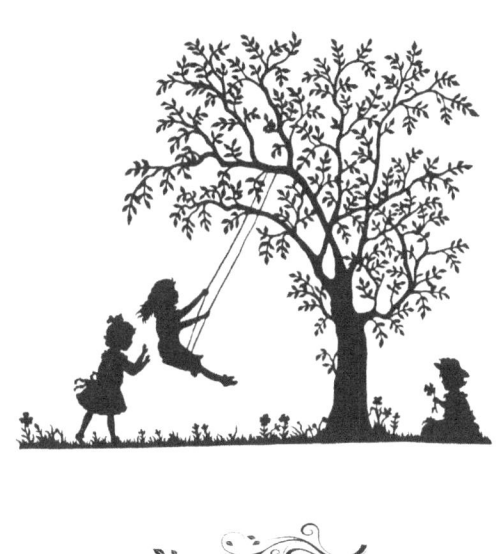

The poetry of **Robert Louis Stevenson**

With Piano Accompaniment

Rob Honey

Edited by Tricia Romriell

To Alison Cunningham
From Her Boy

For the long nights you lay awake
And watched for my unworthy sake:
For your most comfortable hand
That led me through the uneven land:
For all the story-books you read:
For all the pains you comforted:

For all you pitied, all you bore,
In sad and happy days of yore:--
My second Mother, my first Wife,
The angel of my infant life--
From the sick child, now well and old,
Take, nurse, the little book you hold!

And grant it, Heaven, that all who read
May find as dear a nurse at need,
And every child who lists my rhyme,
In the bright, fireside, nursery clime,
May hear it in as kind a voice
As made my childish days rejoice!

R. L. S.

Music Copyright 2010 Studio Bee Music, Inc.
Copyright of Piano Arrangements 2019 Rob Honey Music
All rights reserved.
studiobeemusic@yahoo.com

© 2019 Rob Honey. All Rights Reserved.
ISBN 978-1-79475-495-9

Time to Rise

A birdie with a yellow bill
Hopped upon my window sill,
Cocked his shining eye and said:
"Ain't you 'shamed, you sleepy-head!

Sleepy-Heads Awaking 4
The Swing 10
Pirate Story 16
The Flowers 20
The Gardener 24
Where Go the Boats 28
My Shadow 32
The Child at Play 40
Night and Day 46
Travel .. 56
The Dumb Soldier 66
Foreign Lands 70
The Land of Nod 78
Garden Days 84
The Land of Story-Books 88
Block City 96
A Good Boy104
Good and Bad Children 108
The Land of Counterpane 112
Marching Song 116

Sleepy-Heads Awaking

From A Child's Garden of Verses Suite
for Piano and Reader

Music by Rob Honey

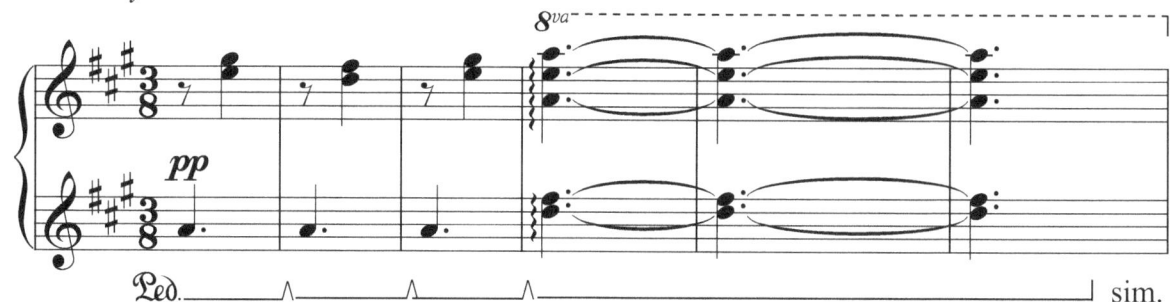

Take a walk with us...

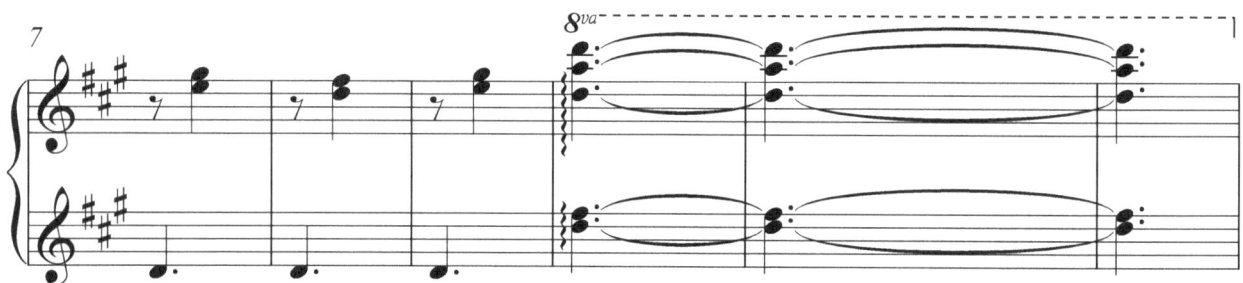

Through Robert Louis Stevenson's...

A Child's Garden of Verses.

with pedal

The Swing

From A Child's Garden of Verses Suite for Piano and Reader

Poem by Robert Louis Stevenson

Music by Rob Honey

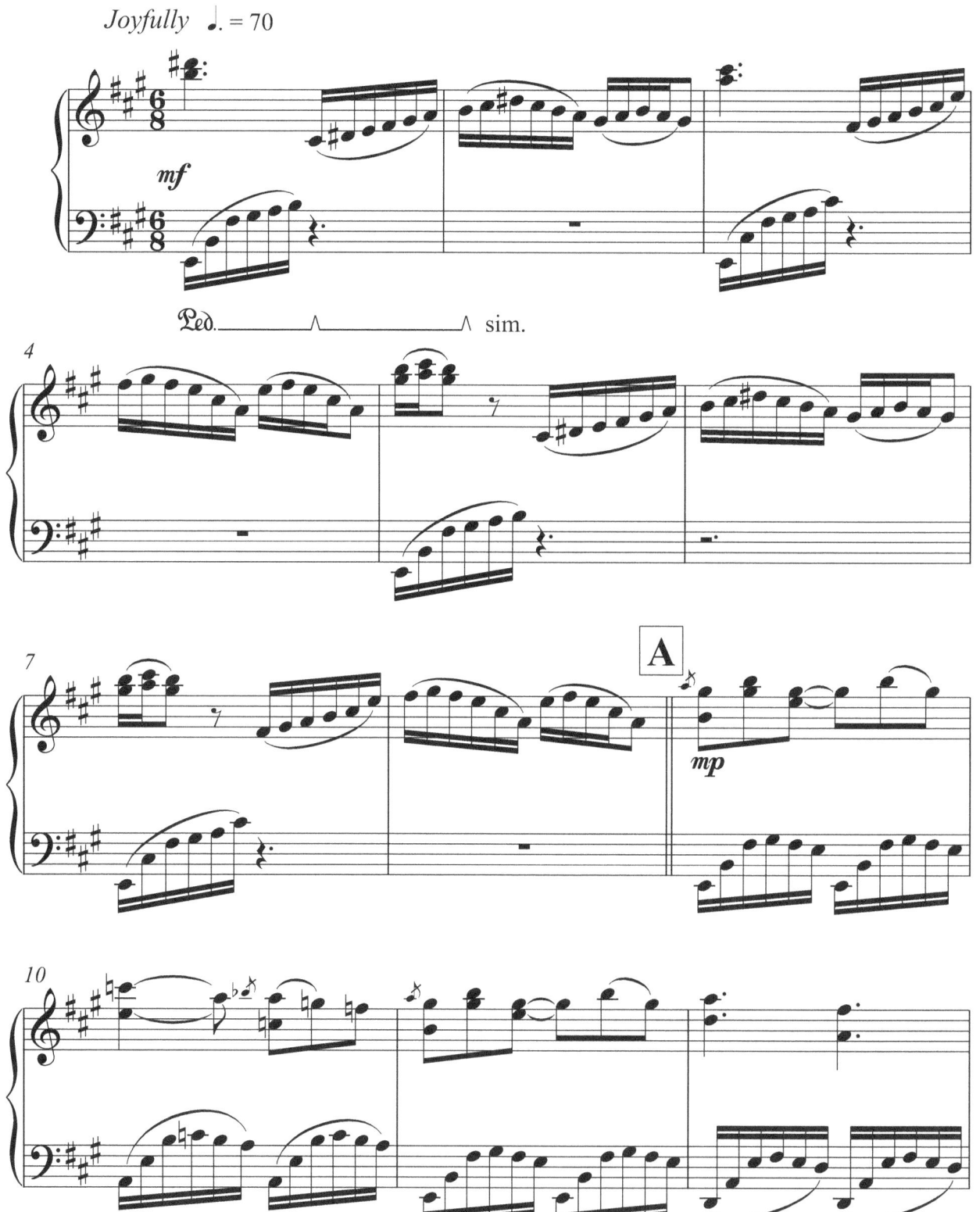

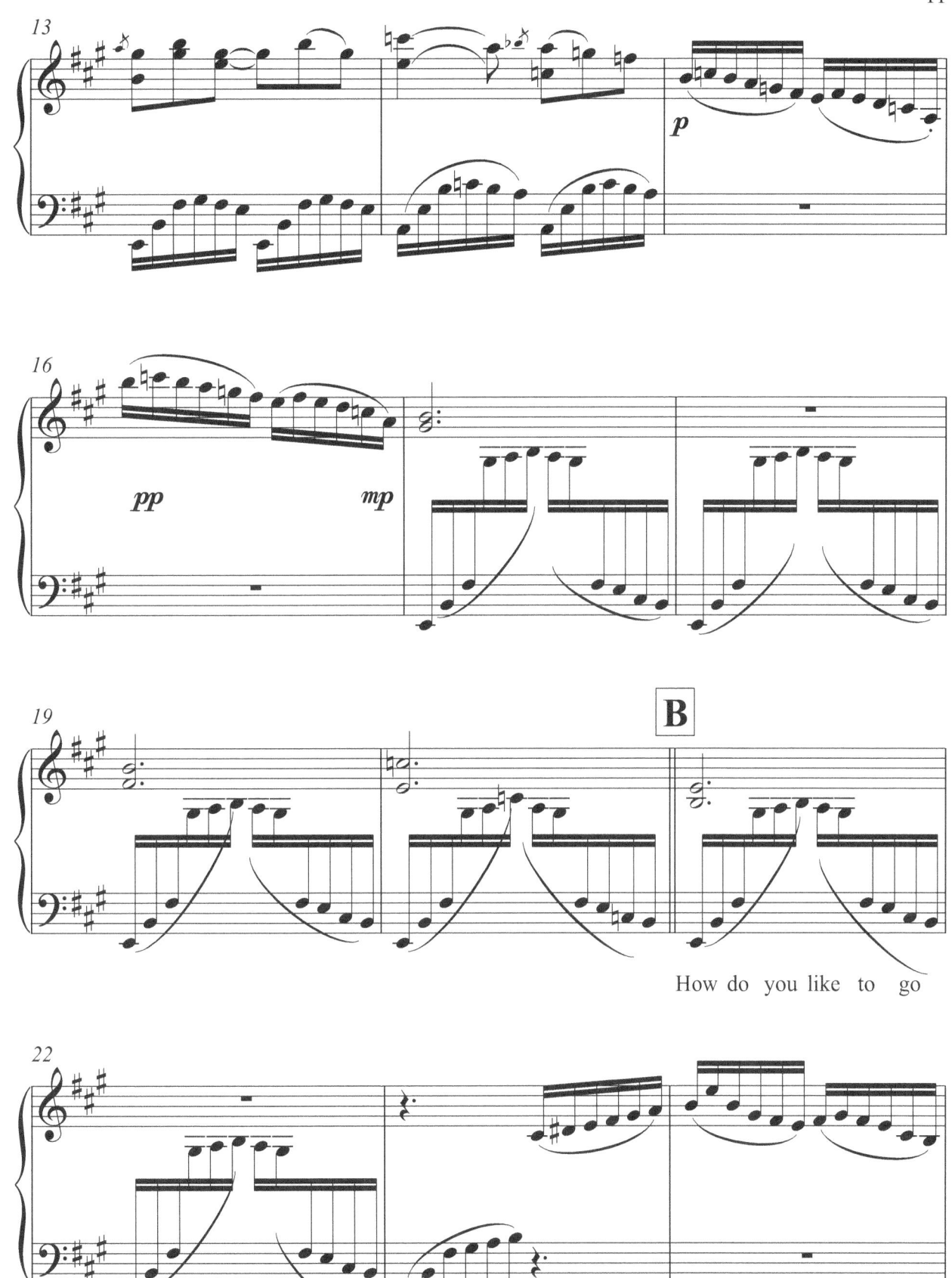

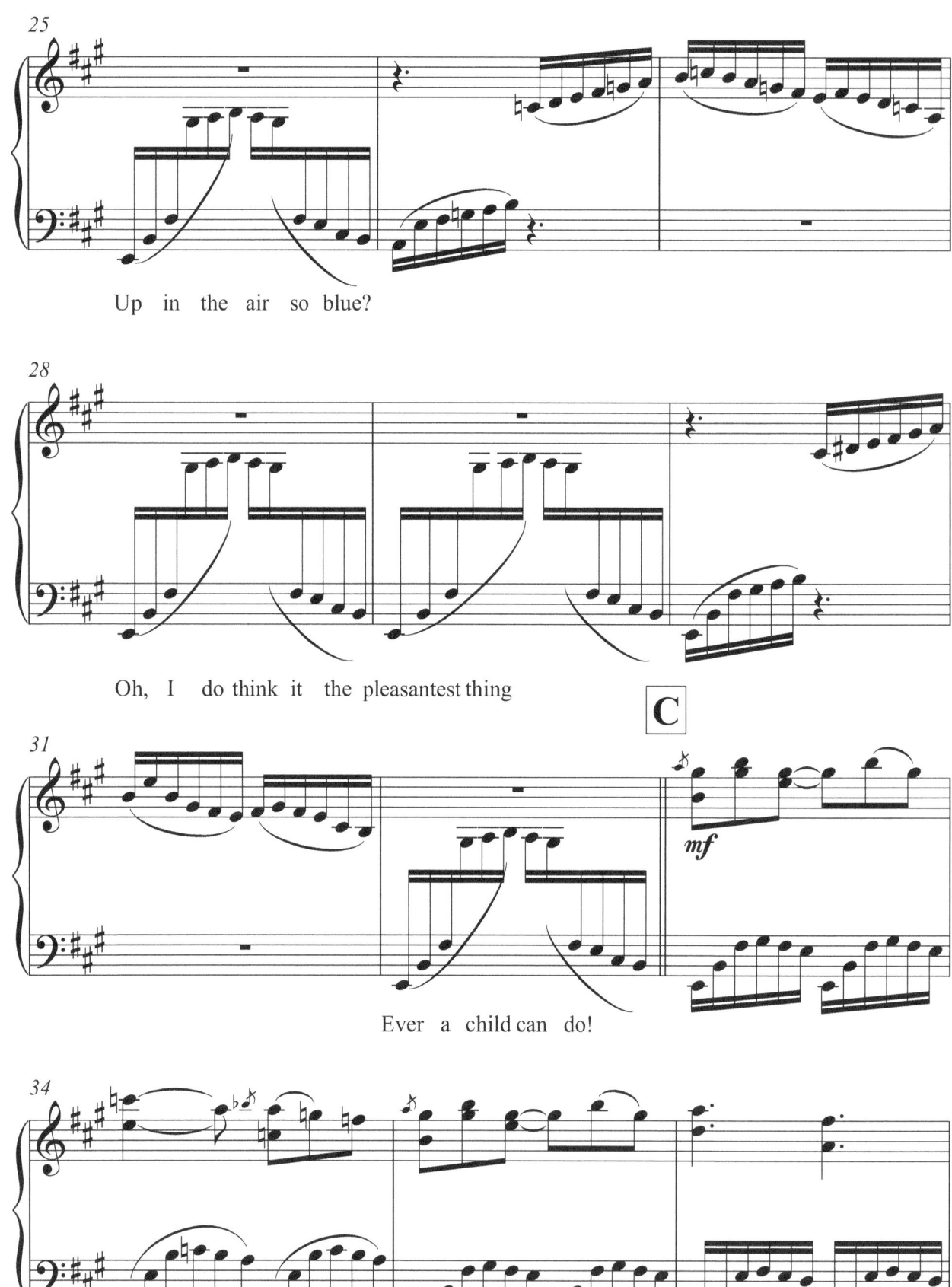

Up in the air and over the wall, Till I can see so wide,

River and trees and cattle and all

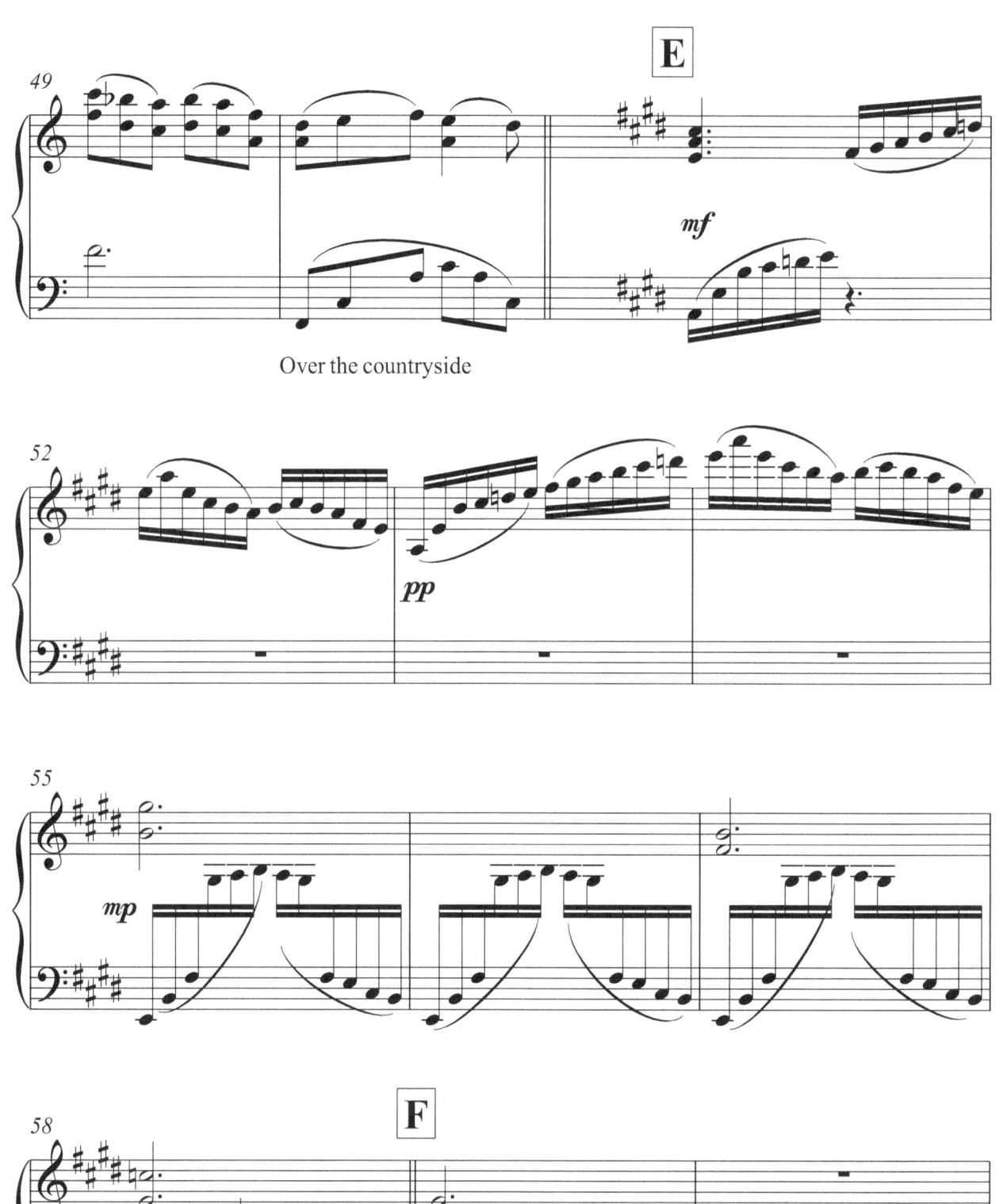

Over the countryside

Till I look down on the garden green,

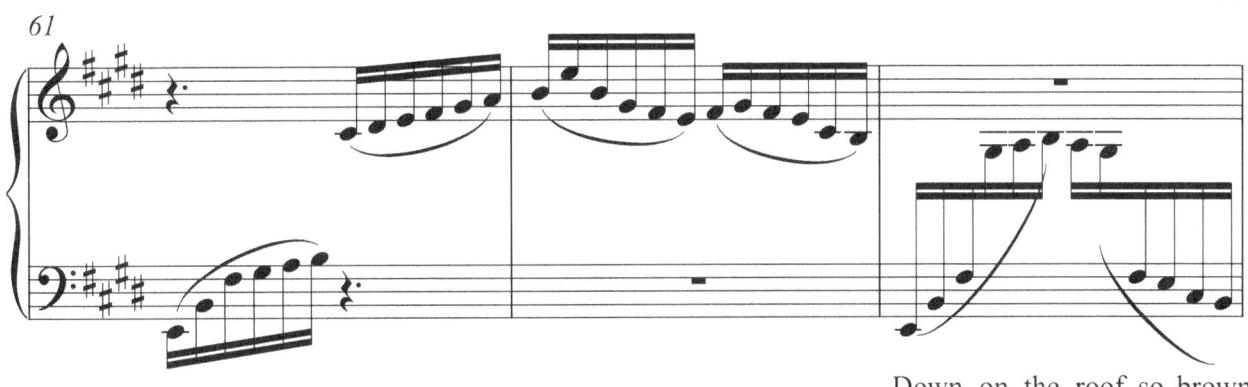
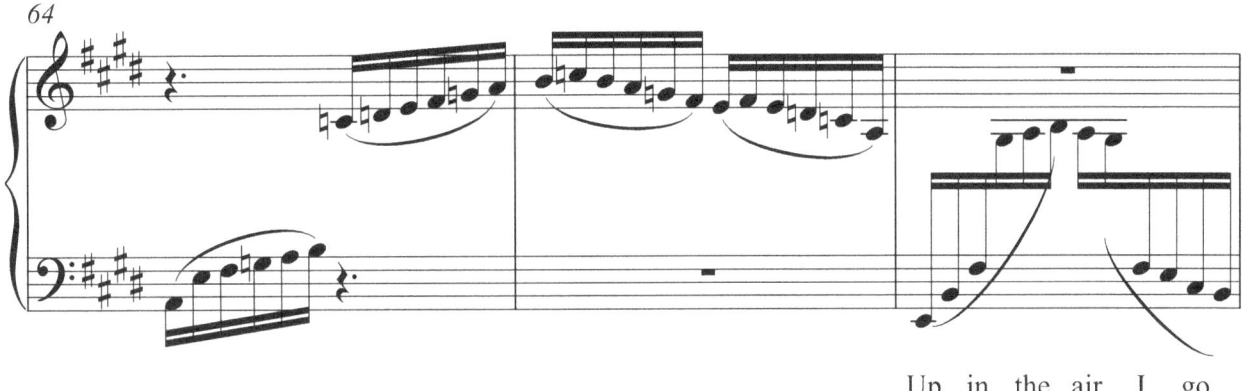
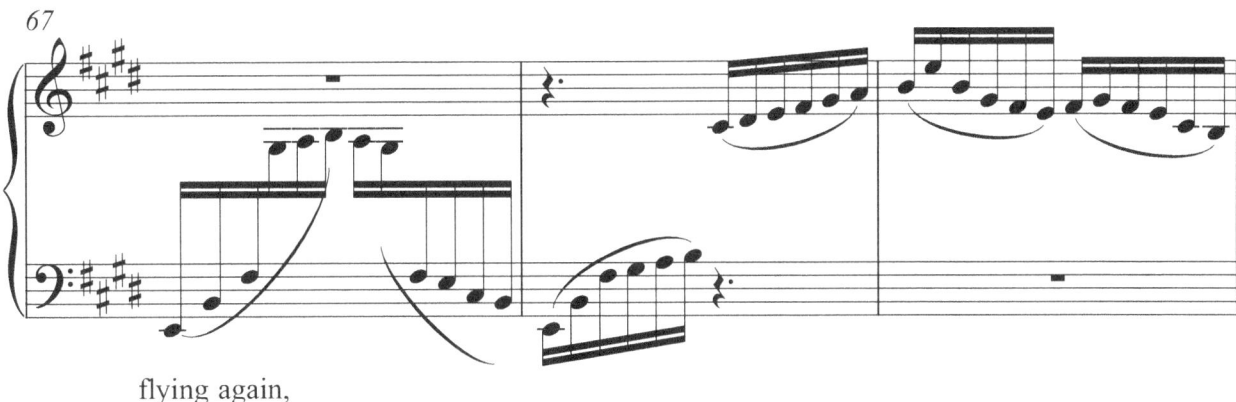
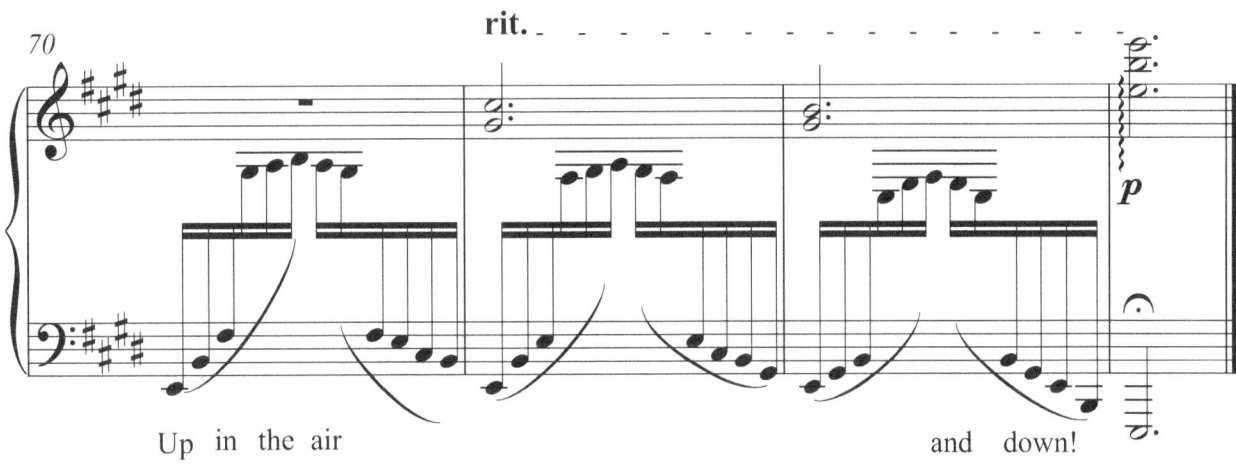

Pirate Story

*From A Child's Garden of Verses Suite
for Piano and Reader*

Poem by Robert Louis Stevenson

Music by Rob Honey

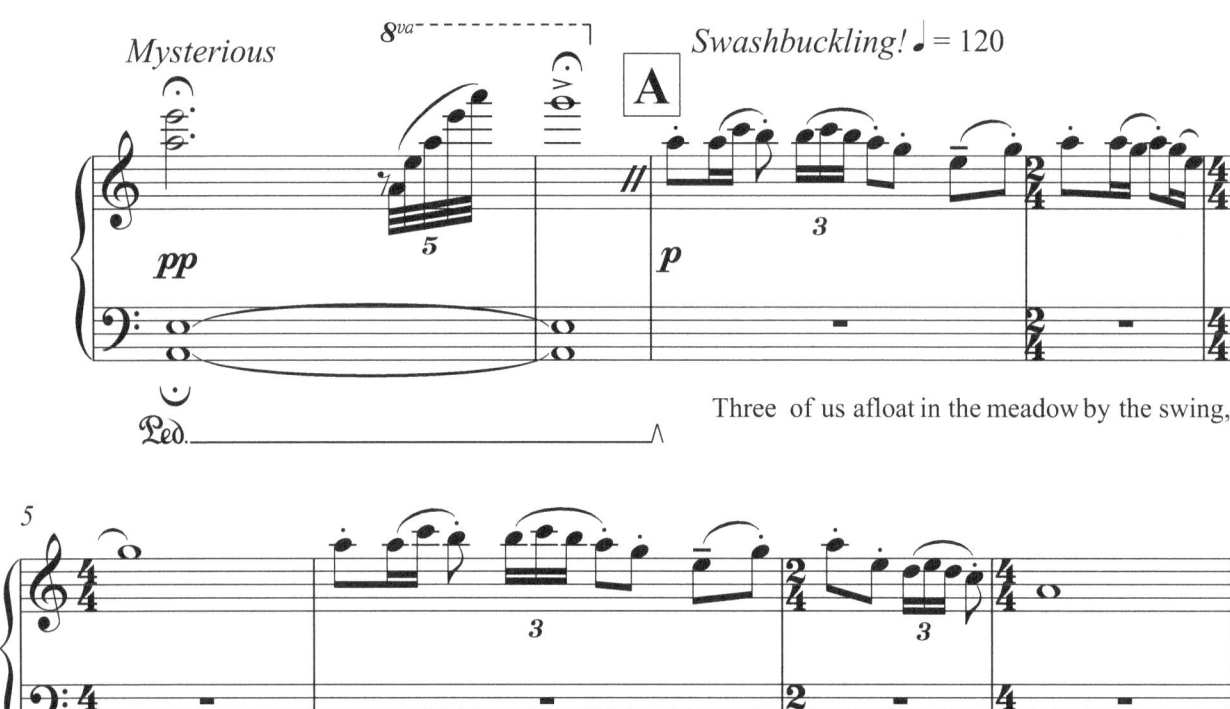

Three of us afloat in the meadow by the swing,

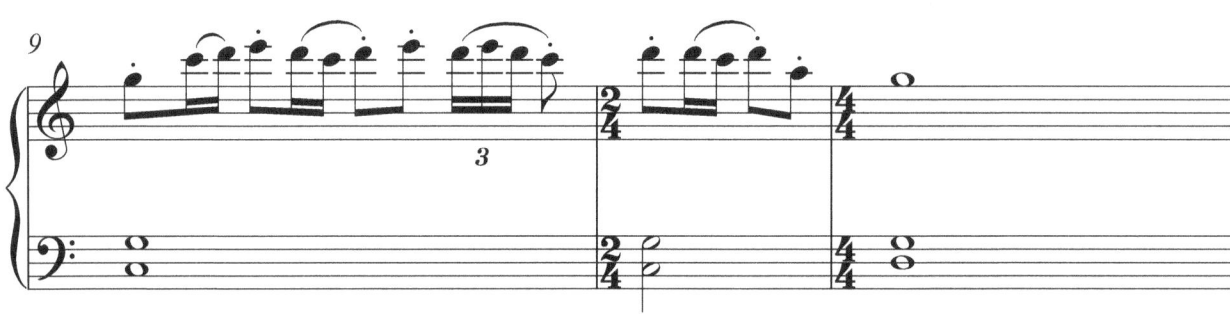

Three of us abroad in the basket on the lea.

Winds are in the air, they are blowing in the spring, And

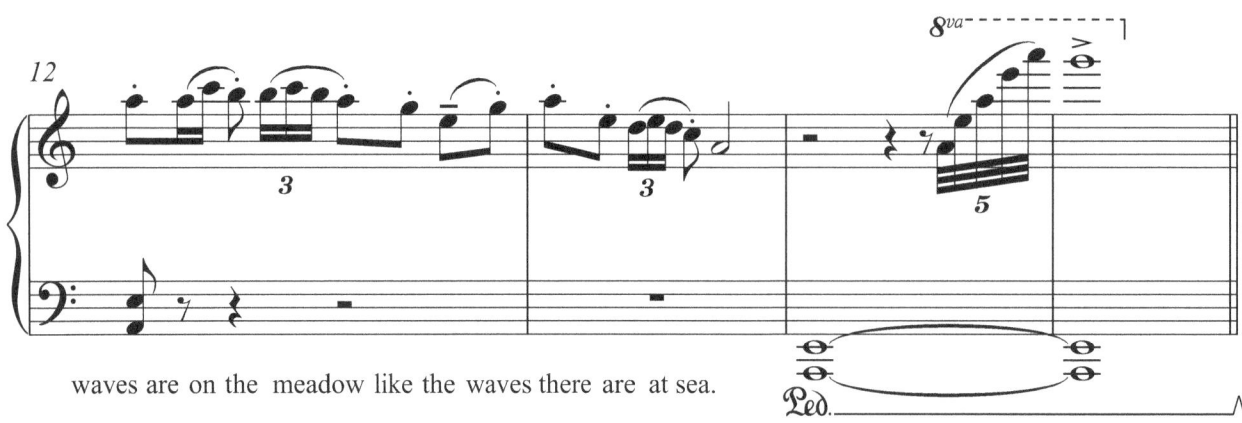

waves are on the meadow like the waves there are at sea.

17

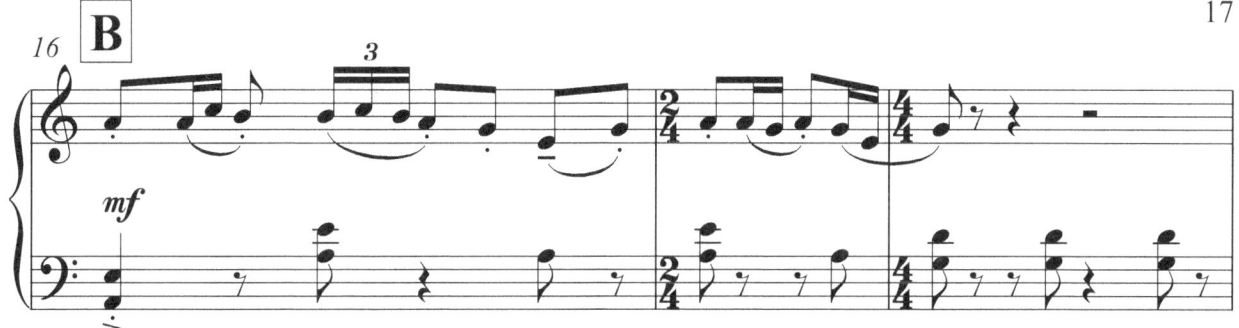

Where shall we adventure, today that we're afloat,

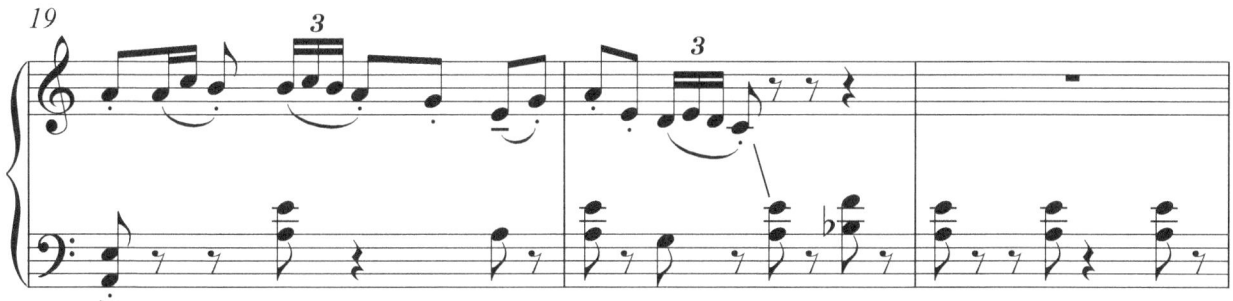

Wary of the weather and steering by a star?

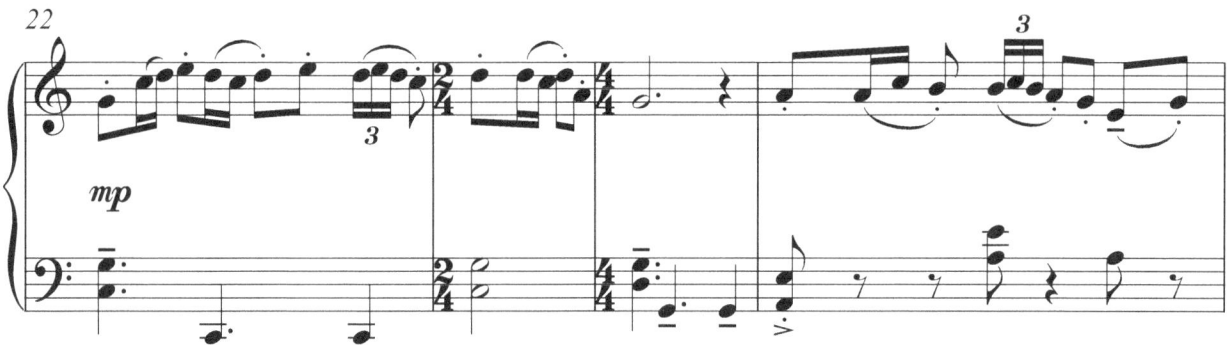

Shall it be to Africa, a steering of the boat, To Providence, or Babylon or off to Malabar?

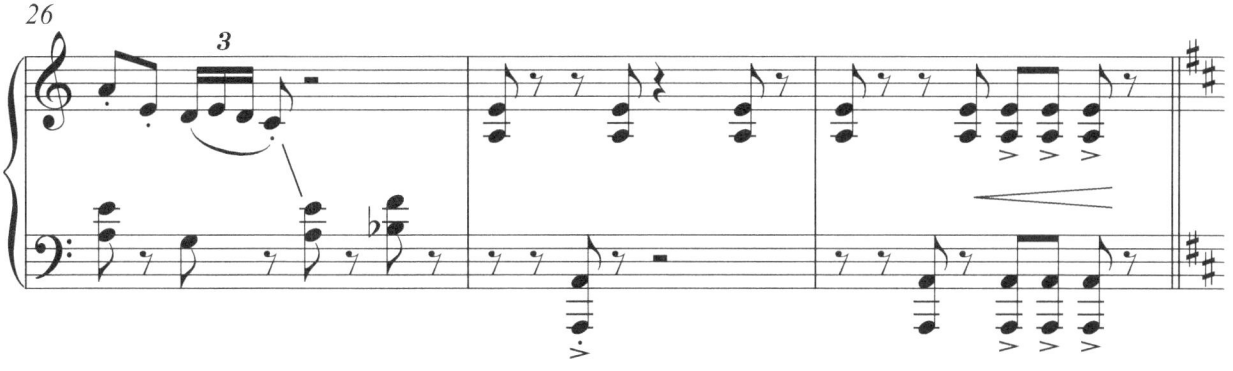

18

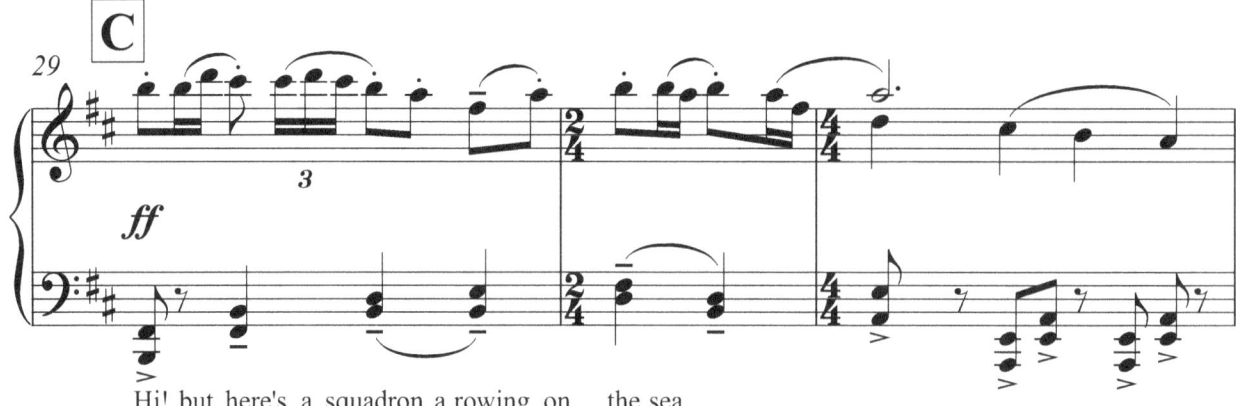

Hi! but here's a squadron a rowing on the sea

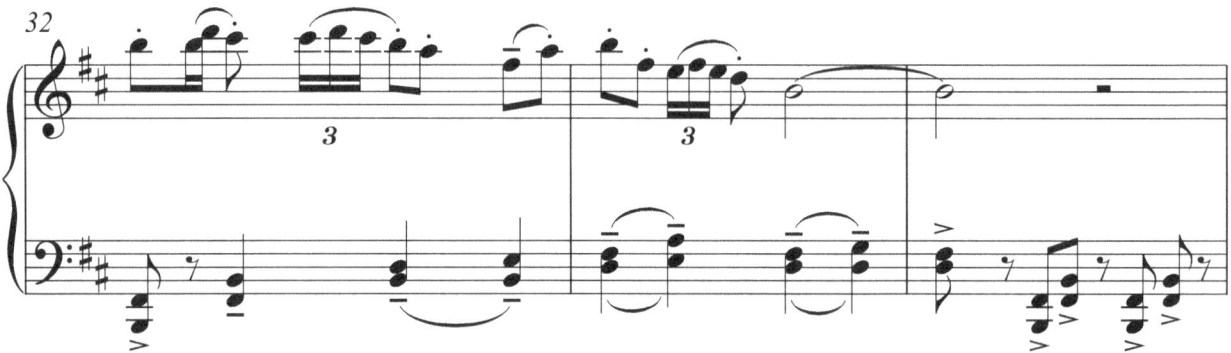

Cattle on the meadow a - charging with a roar!

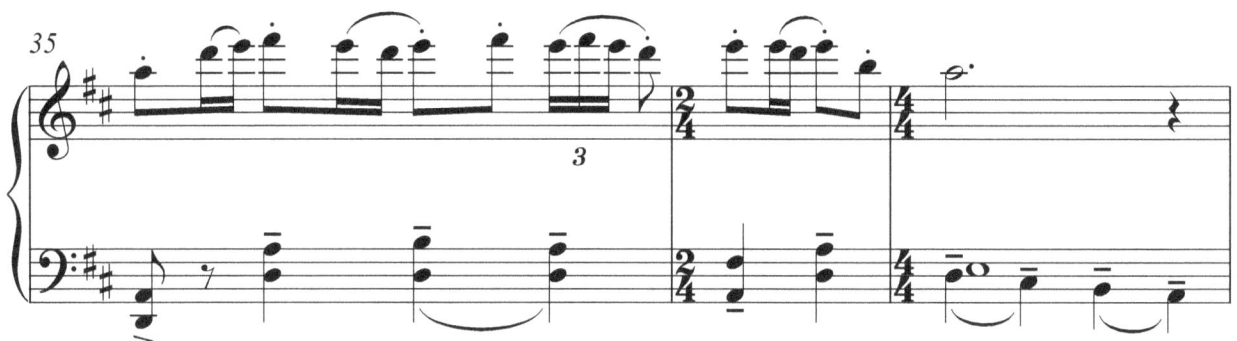

Quick, and we'll escape them, they're as mad as they can be,

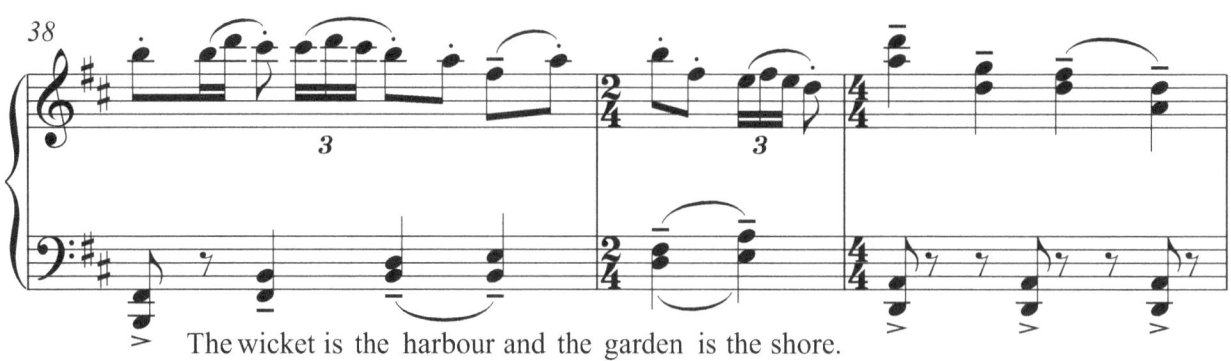

The wicket is the harbour and the garden is the shore.

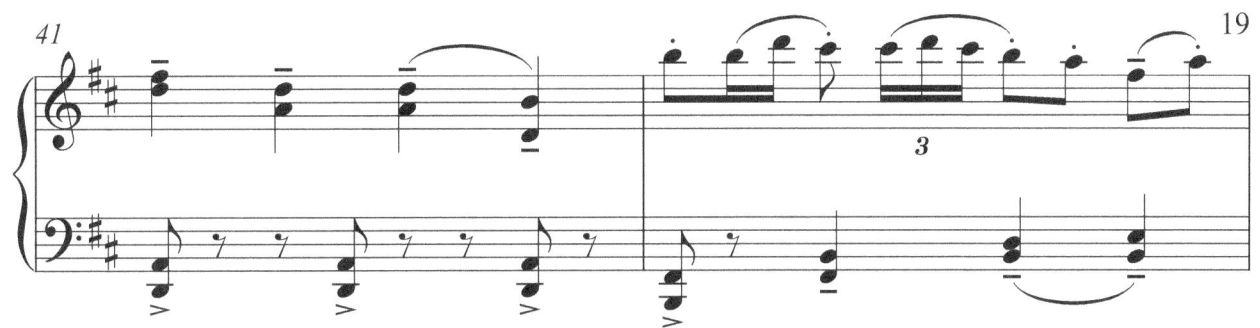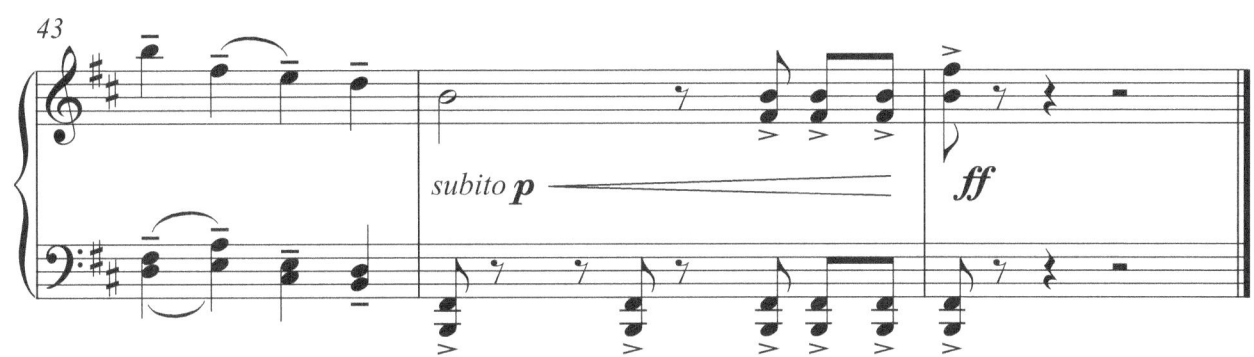

The Flowers

From A Child's Garden of Verses Suite for Piano and Reader

Poem by Robert Louis Stevenson

Music by Rob Honey

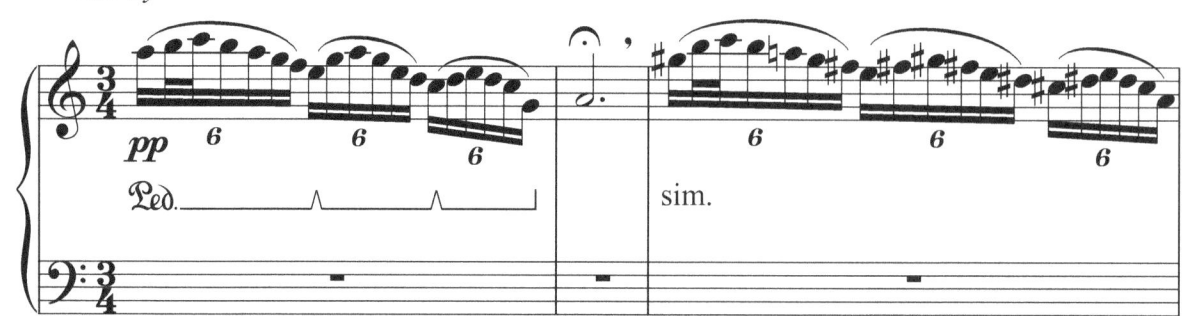

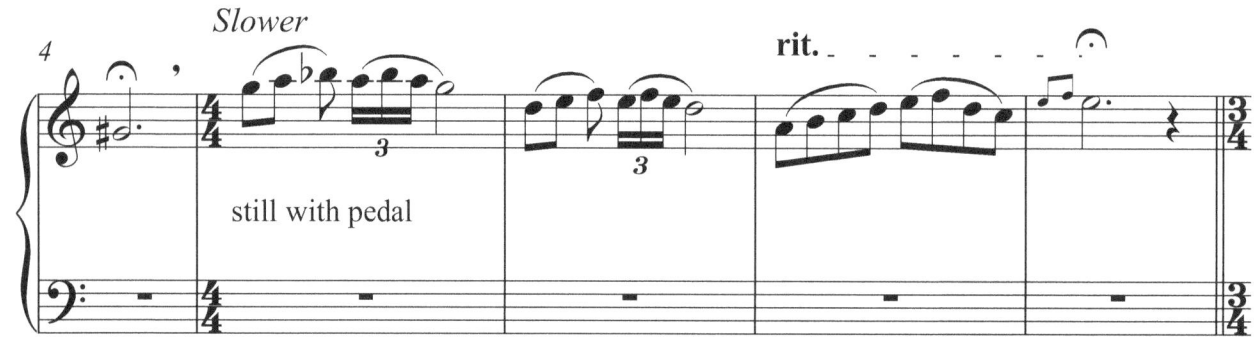

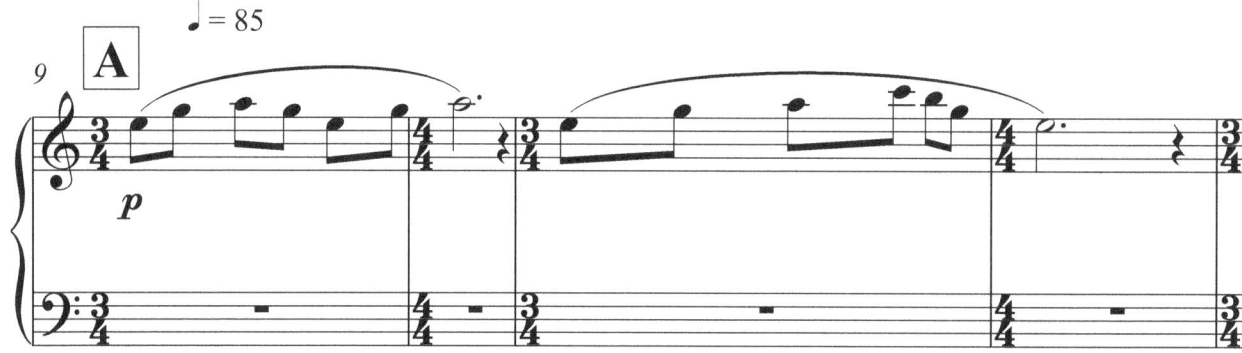

All the names I know from nurse: Gardener's garters, Shepherd's purse,

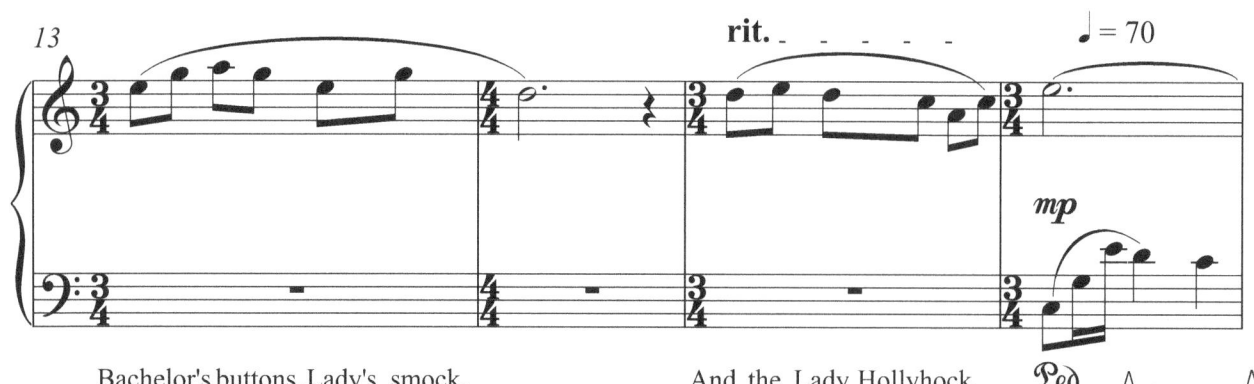

Bachelor's buttons, Lady's smock. And the Lady Hollyhock.

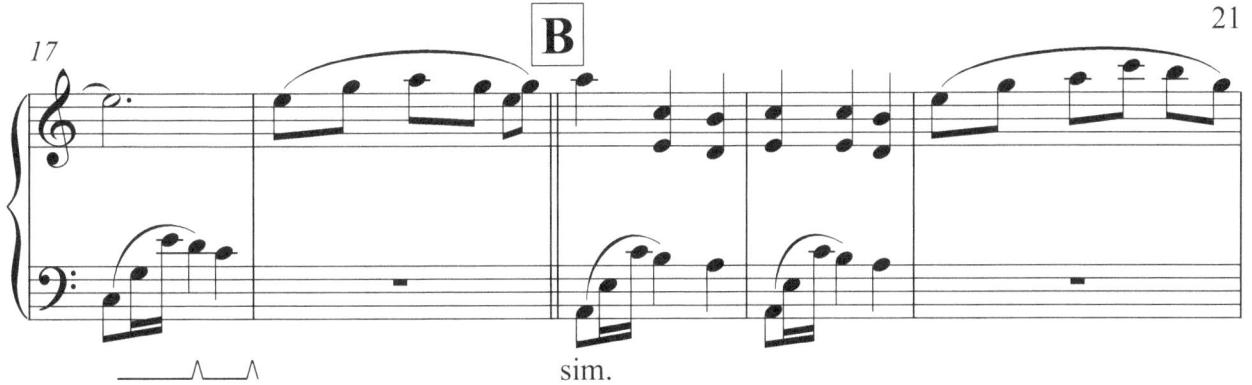
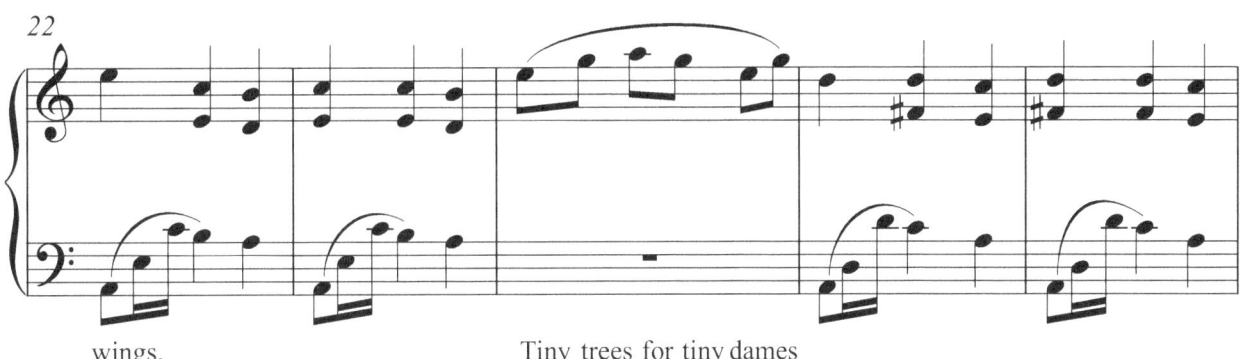
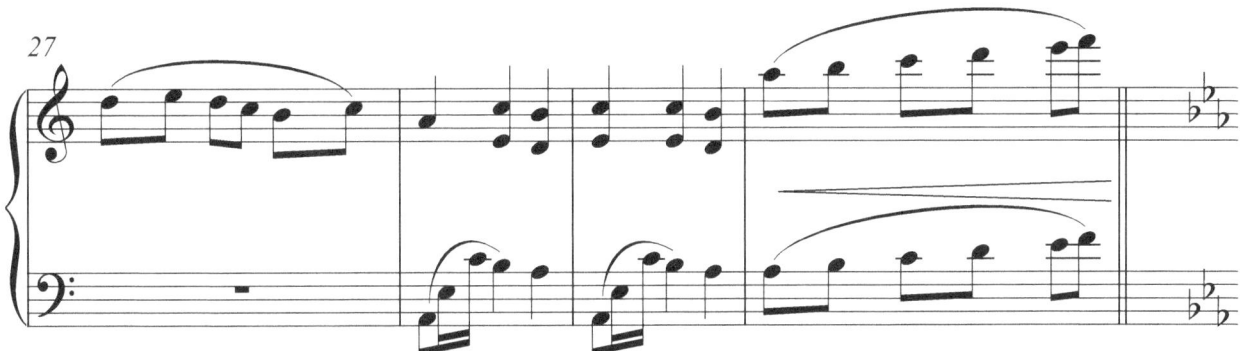
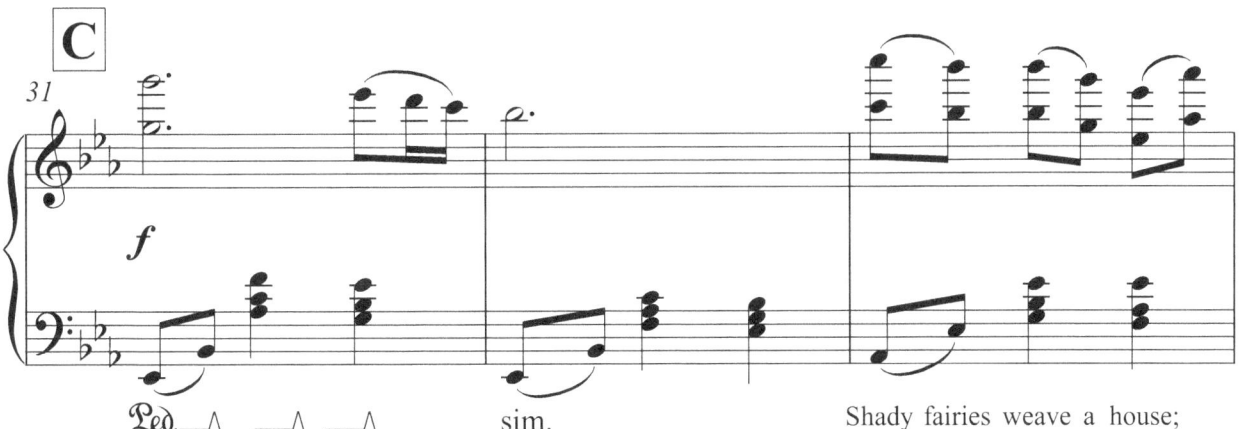

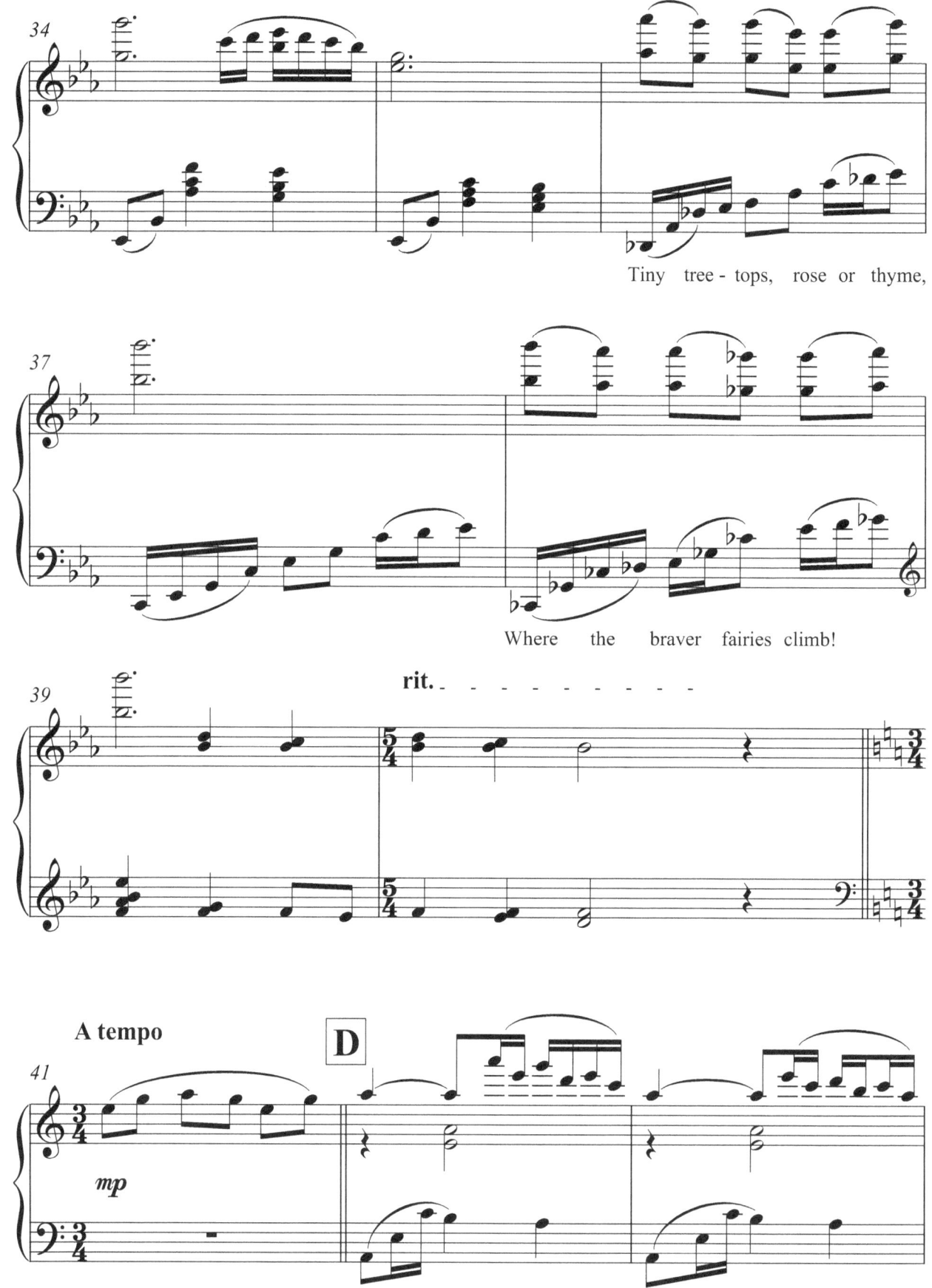

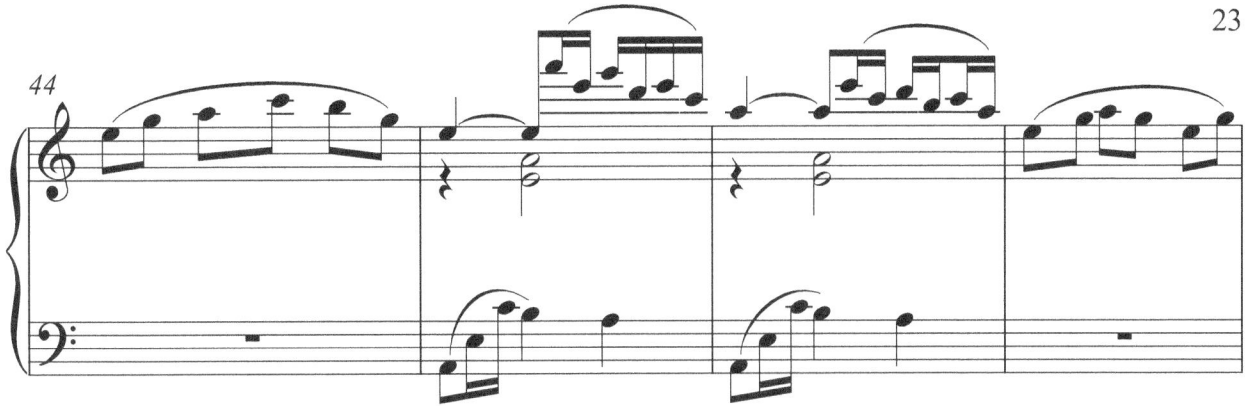

But the fairest woods are these; Where, if I were not so

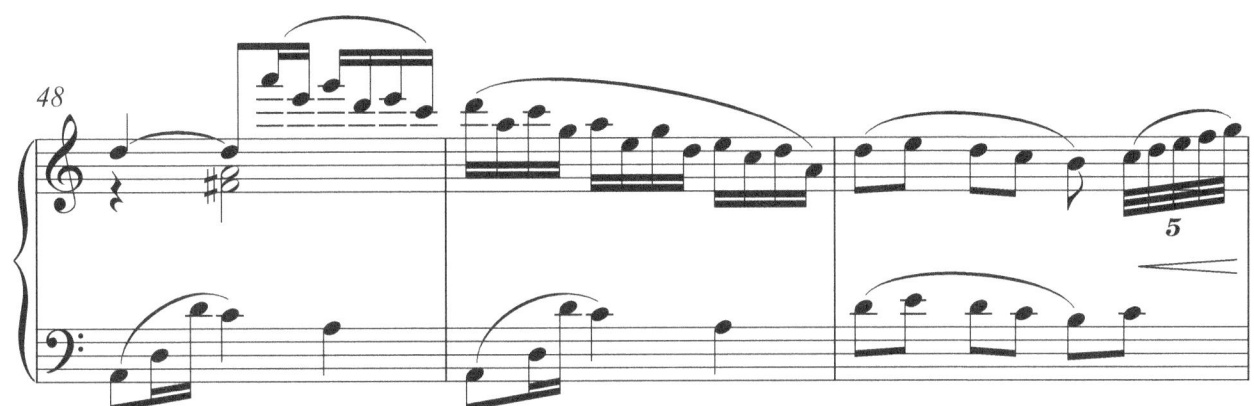

tall, I should live for good and all.

24

The Gardener

From A Child's Garden of Verses Suite for Piano and Reader"

Poem by Robert Louis Stevenson

Music by Rob Honey

Grumpily ♩=90

The gardener does not love to talk. He makes me keep the gravel walk; And when he puts his tools away,

He locks the door and takes the key.

26

And winter comes with pinching toes, When in the garden bare and brown

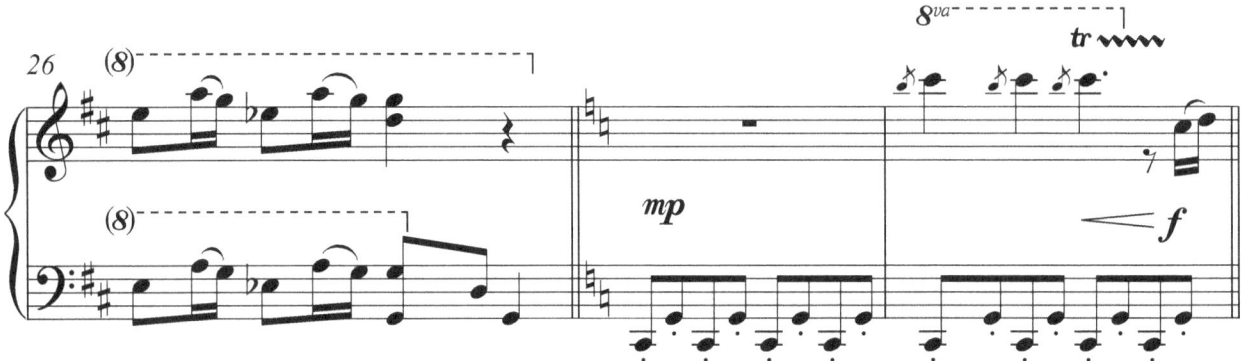

You must lay your barrow down.

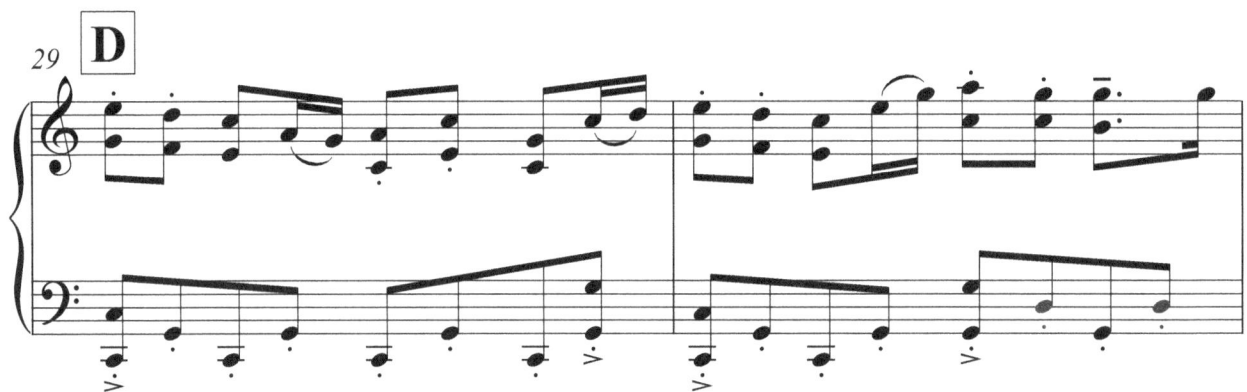

Well now, and while the summer stays, To profit by these garden days

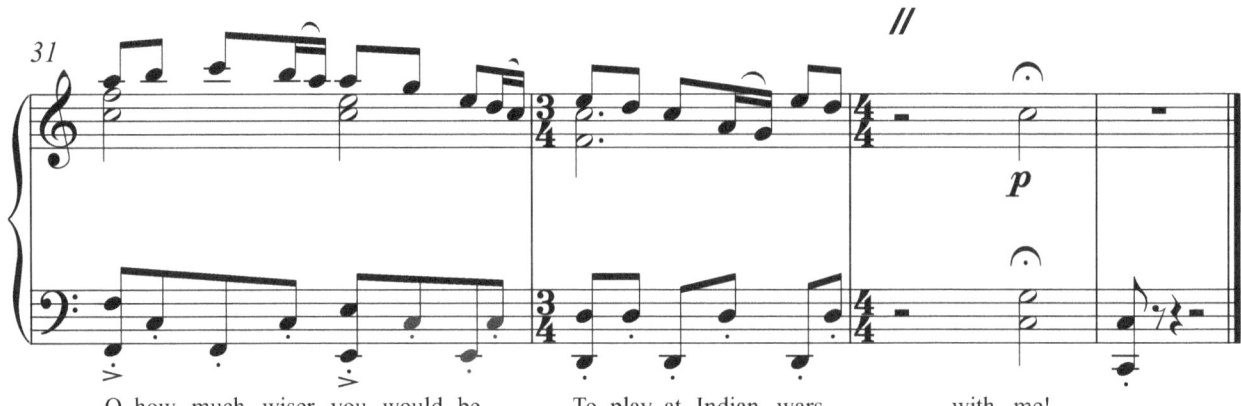

O how much wiser you would be To play at Indian wars with me!

At The Sea-side

When I was down beside the sea
A wooden spade they gave to me
 To dig the sandy shore.

My holes were empty like a cup.
In every hole the sea came up,
 Till it could come no more.

Where Go the Boats

From A Child's Garden of Verses Suite for Piano and Reader

Poem by Robert Louis Stevenson

Music by Rob Honey

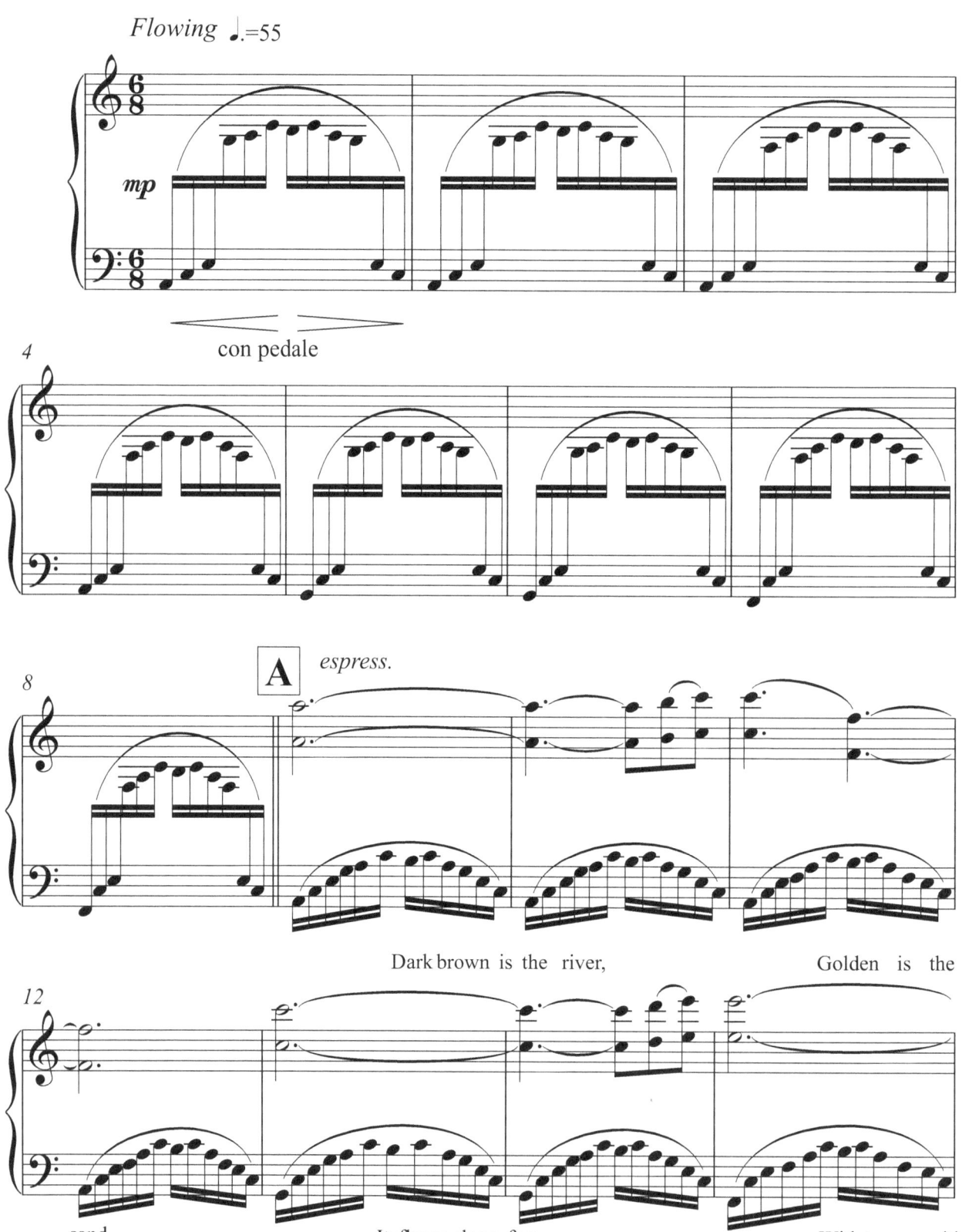

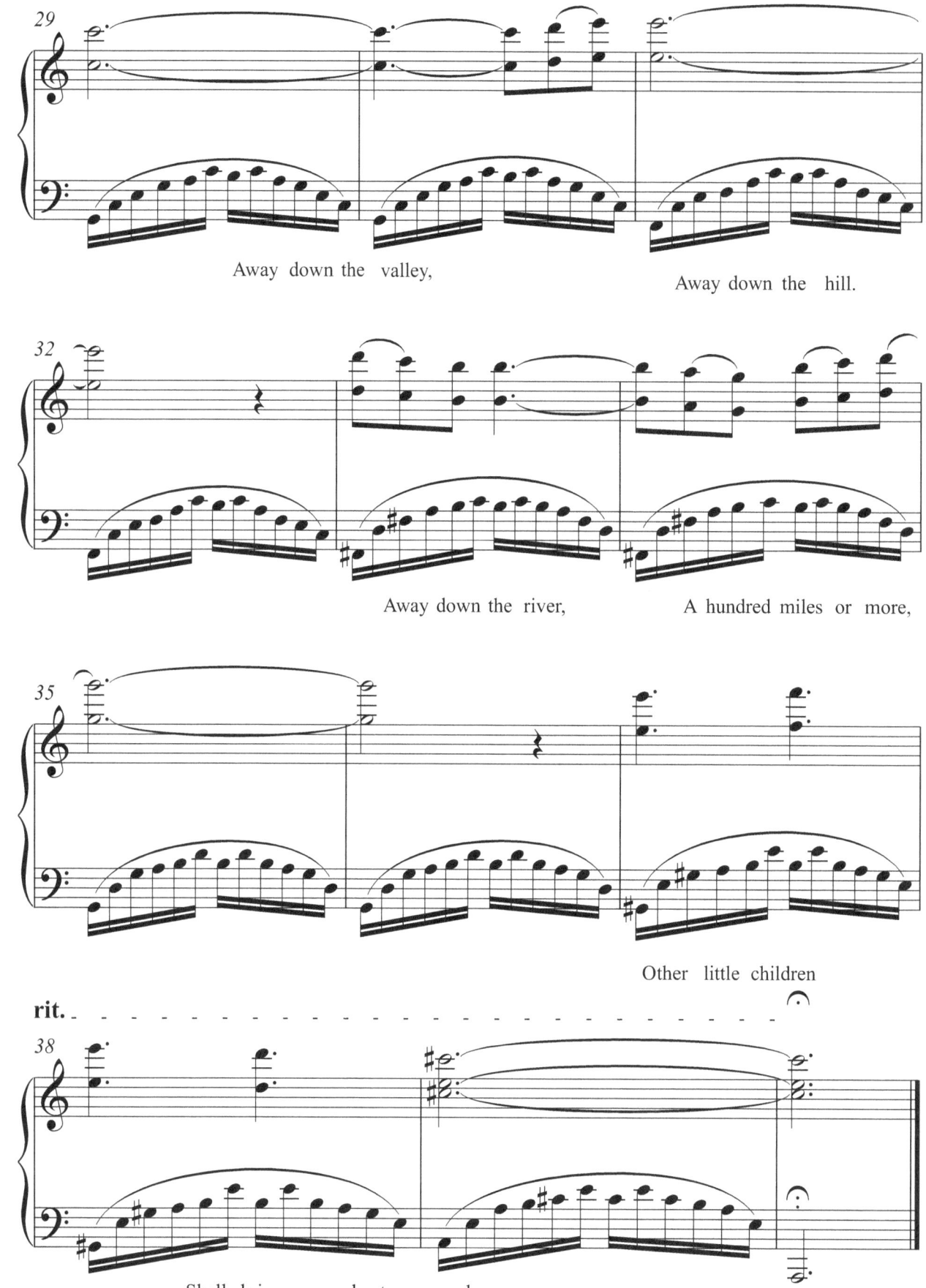

A Good Play

We built a ship upon the stairs
All made of the back-bedroom chairs,
And filled it full of soft pillows
To go a-sailing on the billows.

We took a saw and several nails,
And water in the nursery pails;
And Tom said, "Let us also take
An apple and a slice of cake;"--
Which was enough for Tom and me
To go a-sailing on, till tea.

We sailed along for days and days,
And had the very best of plays;
But Tom fell out and hurt his knee,
So there was no one left but me.

My Shadow

*From A Child's Garden of Verses Suite
for Piano and Reader*

Poem by Robert Louis Stevenson

Music by Rob Honey

Bouncy and fun ♩ = 180

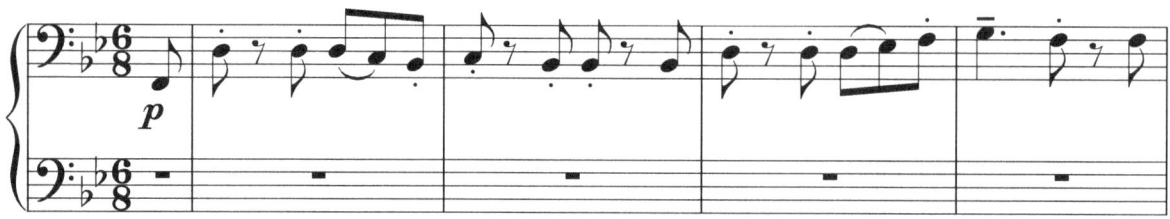

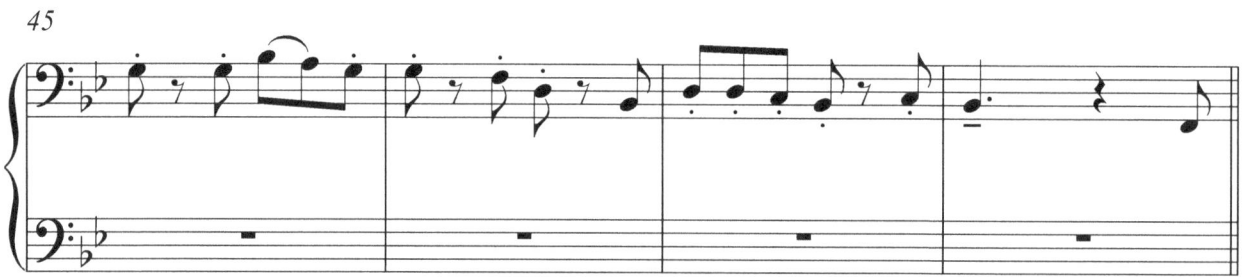

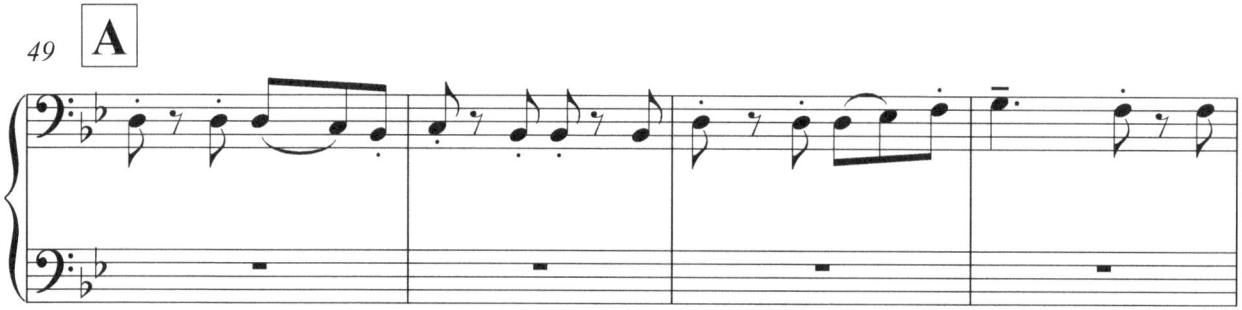

I have a little shadow that goes in and out with me,

And what can be the use of him is more than I can see.

He is very, very like me from the heels up to the head;

And I see him jump before me, when I jump into my bed.

B

The funniest thing about him is the way he likes to grow

Not at all like proper children, which is always very slow;

For he sometimes shoots up taller like an india rubber ball,

He hasn't got a notion of how children ought to play,

And can only make a fool of me in every sort of way.

He stays so close behind me he's a coward you can see;

I'd think shame to stick to nursie as that shadow sticks to me!

One morning, very early,

before the sun was up, I rose and found the shining dew

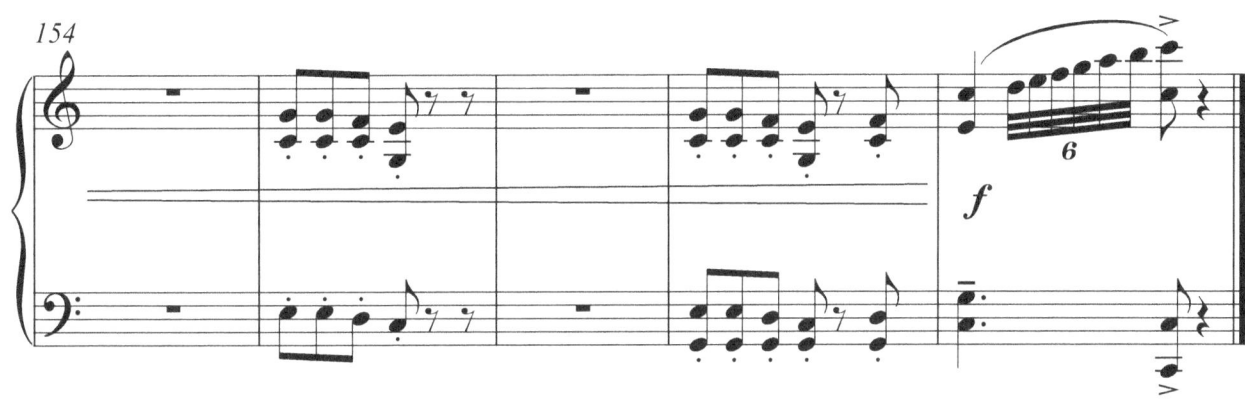

The Child at Play

From A Child's Garden of Verses Suite
for Piano and Reader

Rob Honey

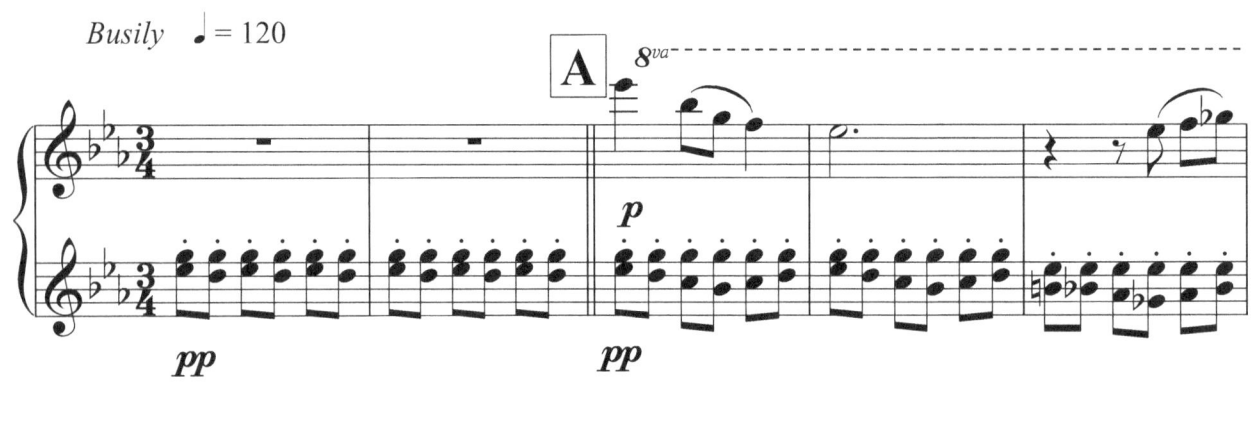
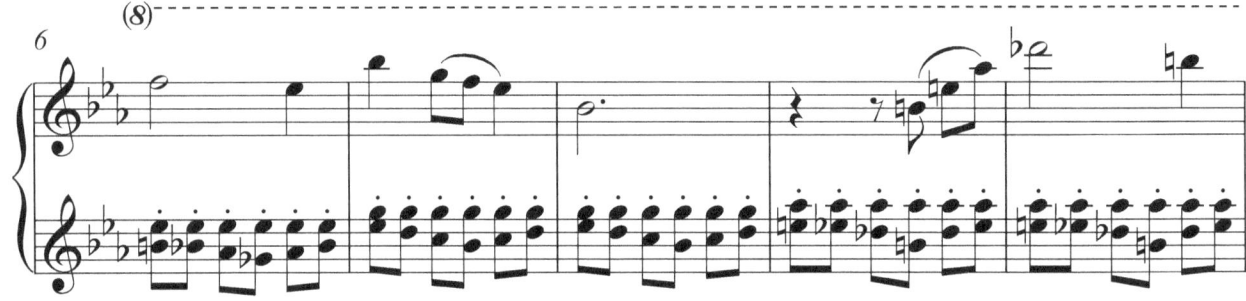
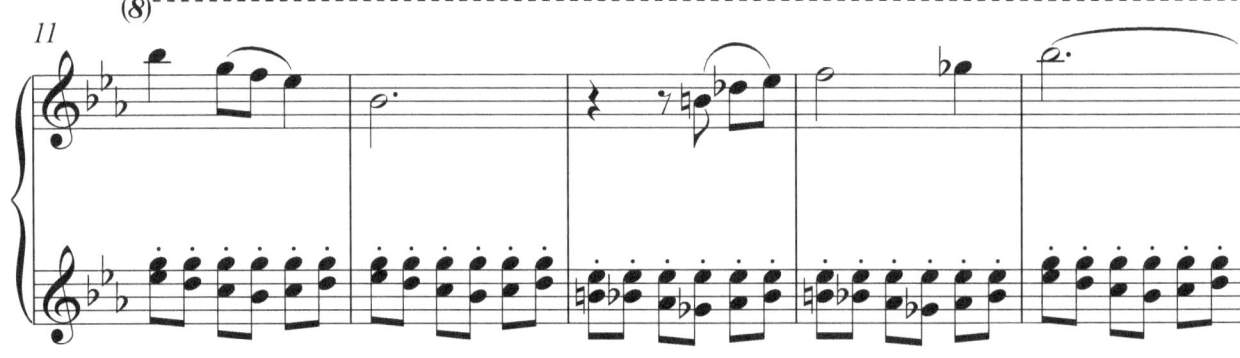

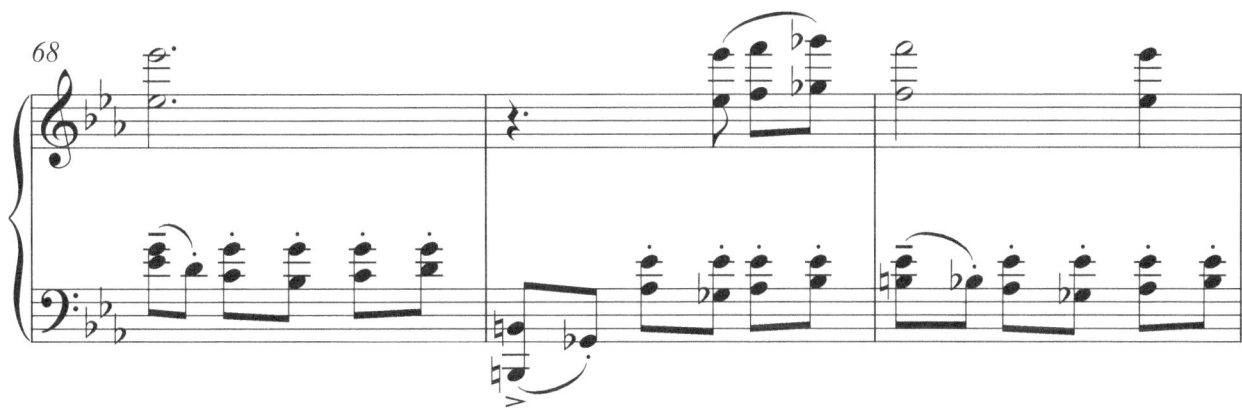

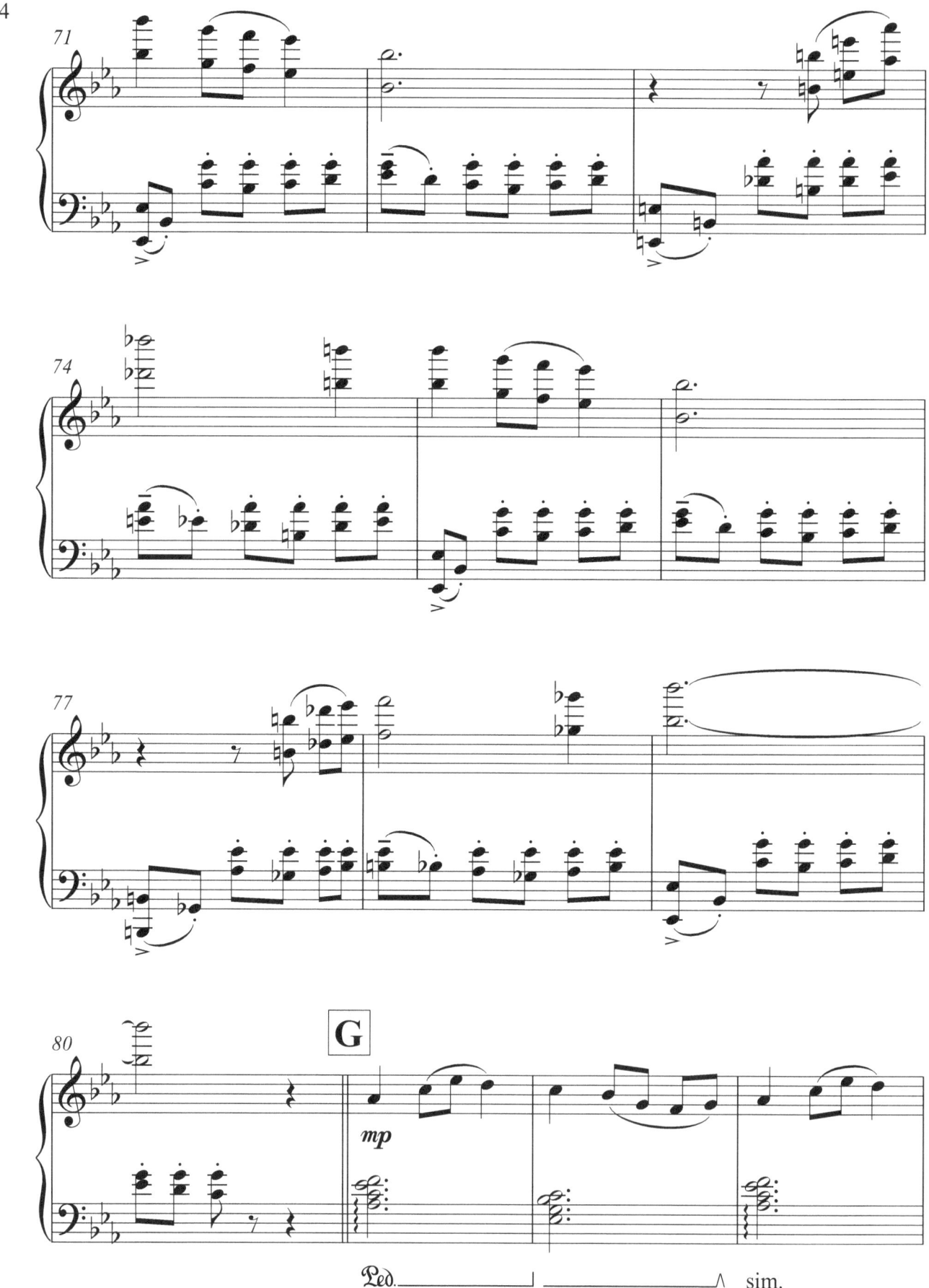

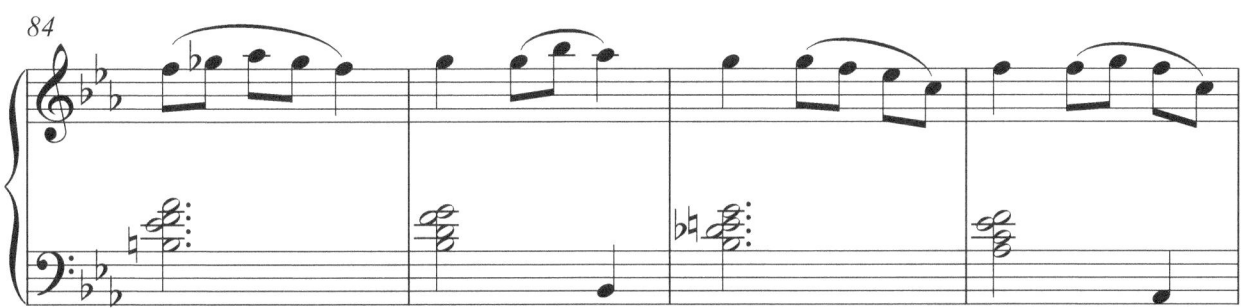
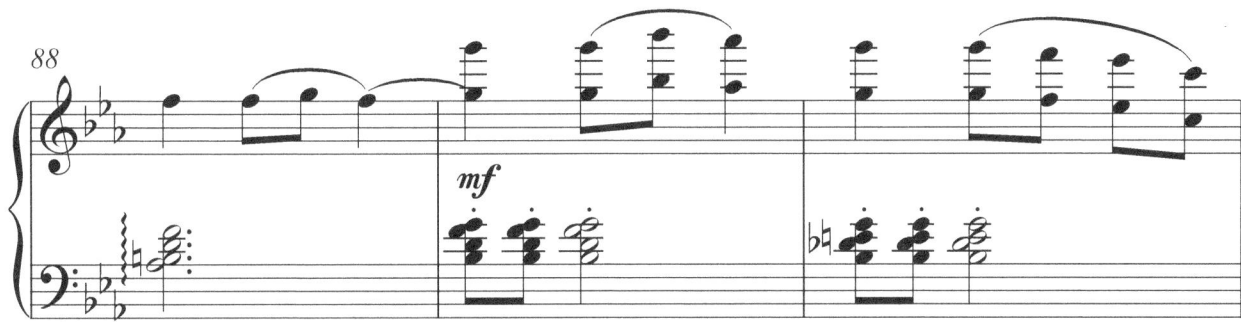

Night and Day

From A Child's Garden of Verses Suite for Piano and Reader

Poem by Robert Louis Stevenson

Music by Rob Honey

When the golden day is done,

Through the closing portal,

Child and garden, flower and sun,

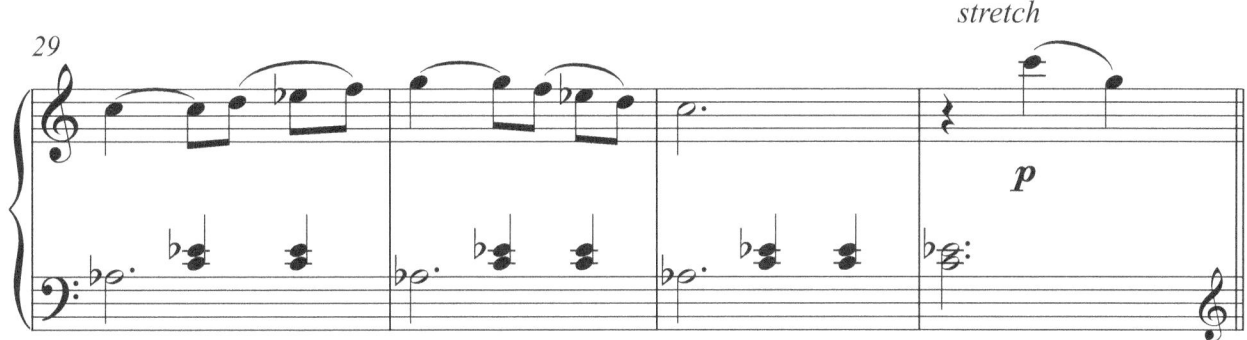

Vanish all things mortal.

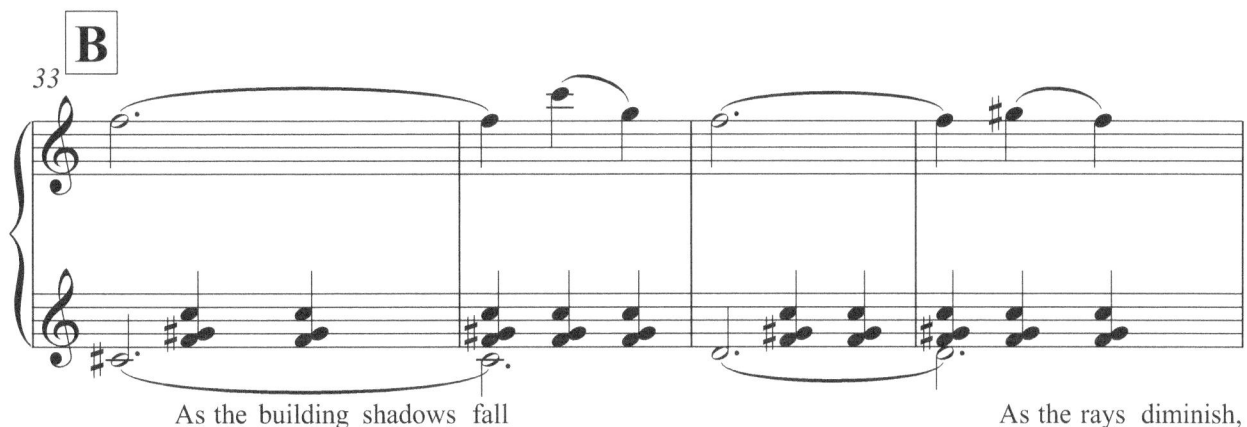

As the building shadows fall As the rays diminish,

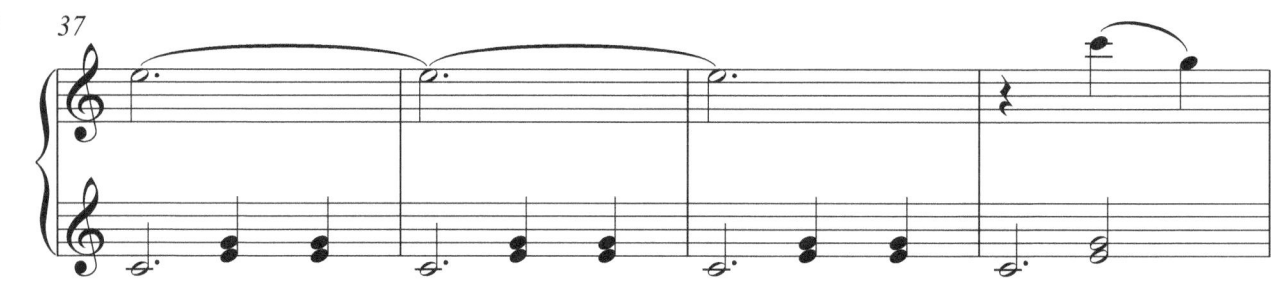

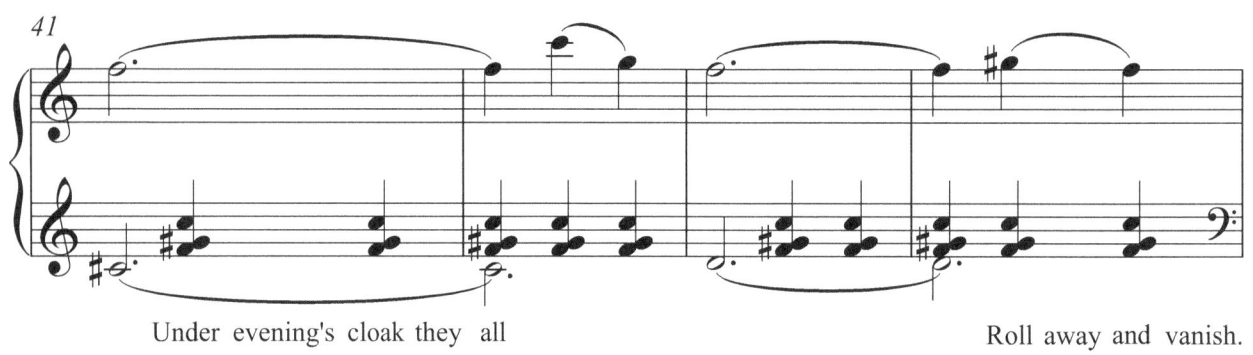

Under evening's cloak they all　　　　　　　　　　Roll away and vanish.

Garden darkened, daisy shut,

Child in bed, they slumber

Glowworm in the hallway rut,

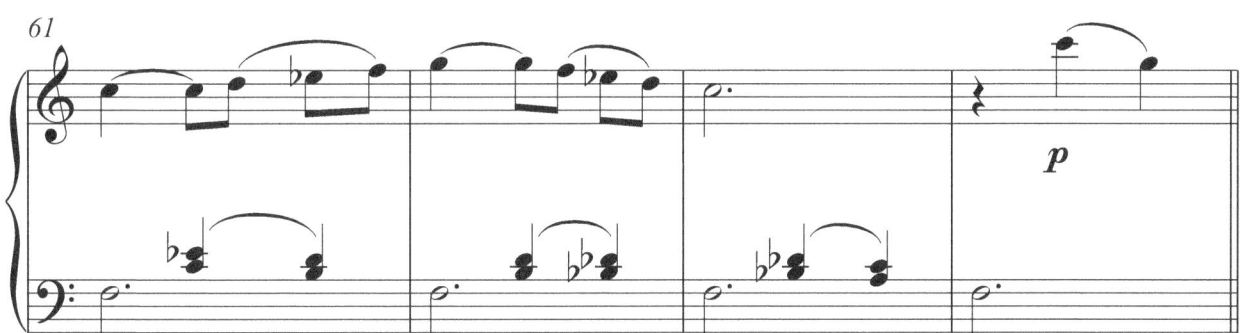

Mice among the lumber.

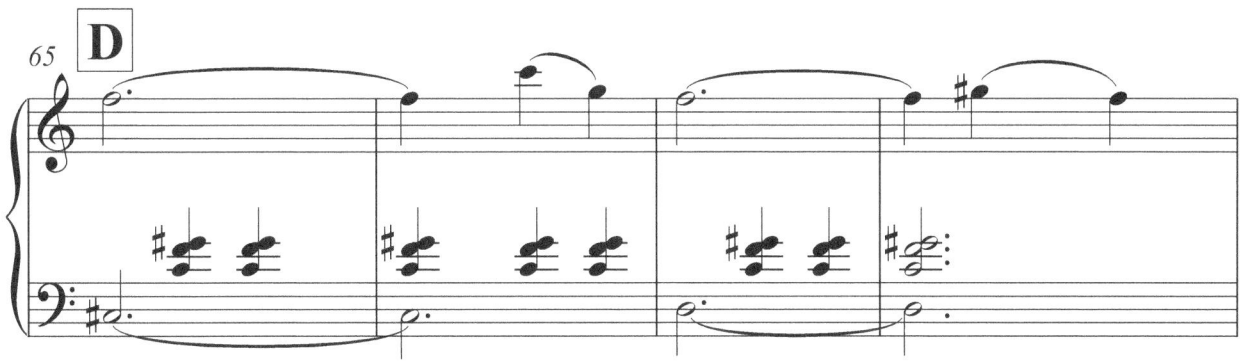

In the darkness houses shine, Parents move the candles;

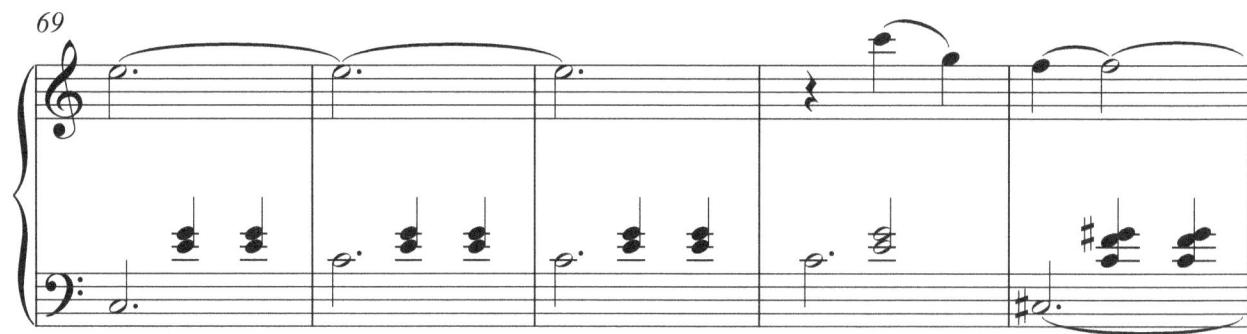

Till on all the

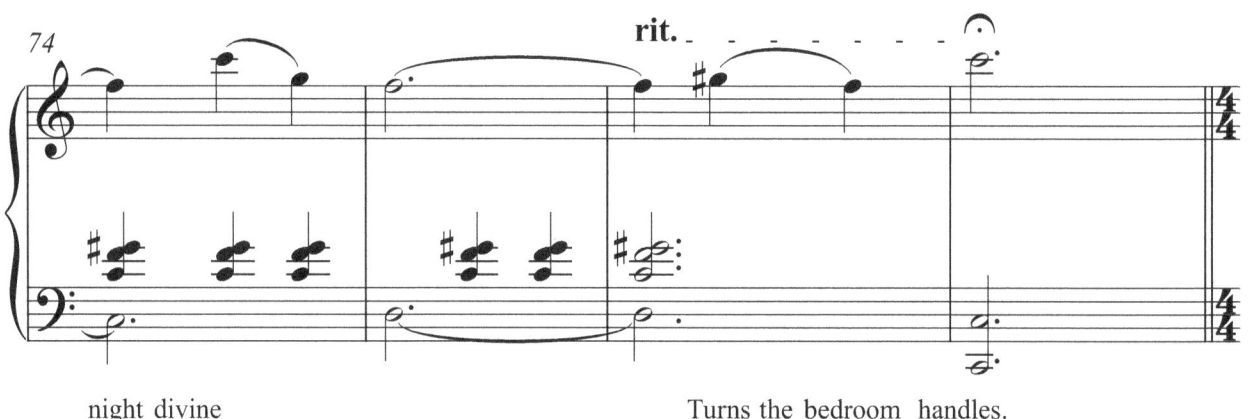

night divine Turns the bedroom handles.

Till at last the day begins In the east a- breaking, In the hedges and the whins

Sleeping birds awaking.

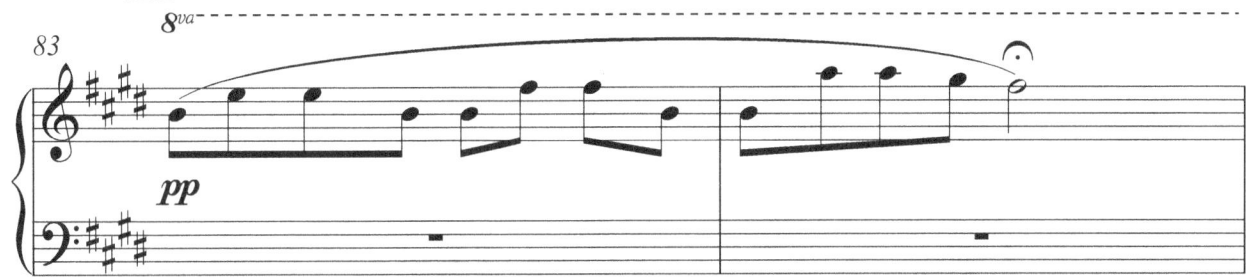

In the darkness shapes of things, Houses, trees and hedges,

Clearer grow; and sparrow's wings Beat on window ledges.

These shall wake the yawning maid; She the door shall open

Finding dew on garden glade And the morning broken.

There my garden grows again Green and rosy painted,

As at eve behind the pane From my eyes it fainted.

Just as it was shut away, Toy-like, in the even, Here I see it glow with day

Under glowing heaven.

Every path and every plot,

Every blush of roses,

Every blue forget - me - not

Where the dew reposes, "Up!" they cry, "the

day is come On the smiling valleys:

We have beat the morning drum. Playmate, join your allies!"

Travel

From A Child's Garden of Verses Suite for Piano and Reader

Poem by Robert Louis Stevenson

Music by Rob Honey

I should like to rise and go

Where the golden apples grow; Where below another sky

Parrot islands anchored lie,

And, watched by cockatoos and goats,

Lonely Crusoes building boats;

Where in sunshine reaching out

Eastern cities, miles about,

Are with mosque and minaret

Among sandy gardens set, And the rich goods from near and far

Hang for sale in the bazaar;

Where the Great Wall round China goes, And on one side the desert blows,

And with the voice and bell and drum, Cities on the other hum;

Where are forests hot as fire, Wide as England, tall as a spire,

Full of apes and cocoanuts And the negro hunters' huts;

Where the knotty crocodile

Lies and blinks in the Nile, And the red flamingo flies

Hunting fish before his eyes;

Where in jungles near and far,

Man - devouring tigers are,

Lying close and giving ear Lest the hunt be drawing near,

Or a comerby be seen Swinging in the palanquin;

Where among the desert sands Some deserted city stands,

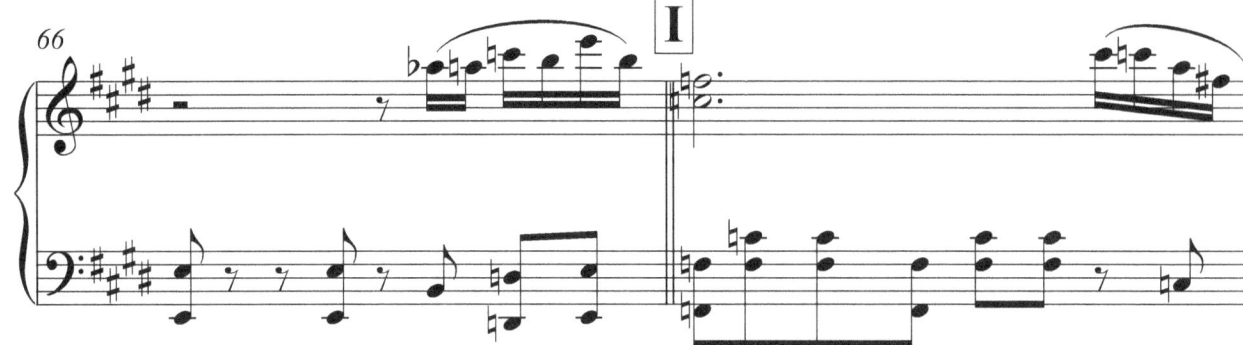

All its children, sweep and prince,

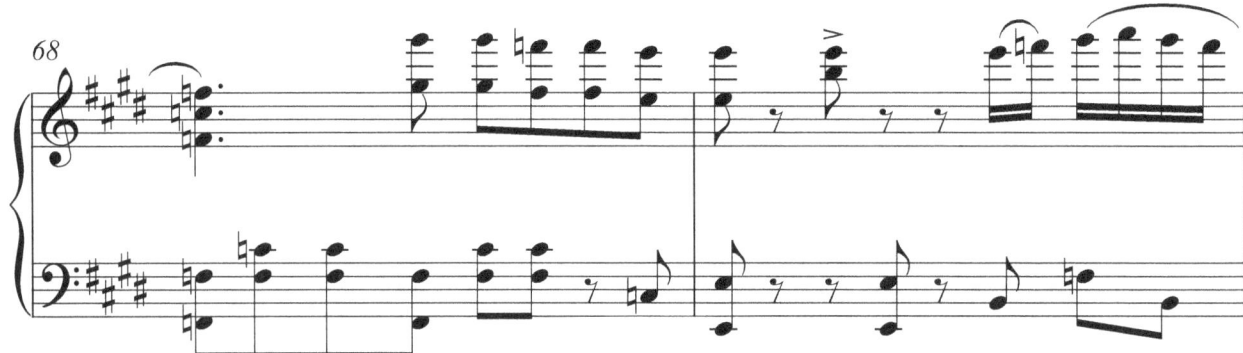

Grown to manhood ages since, Not a foot in street or house,

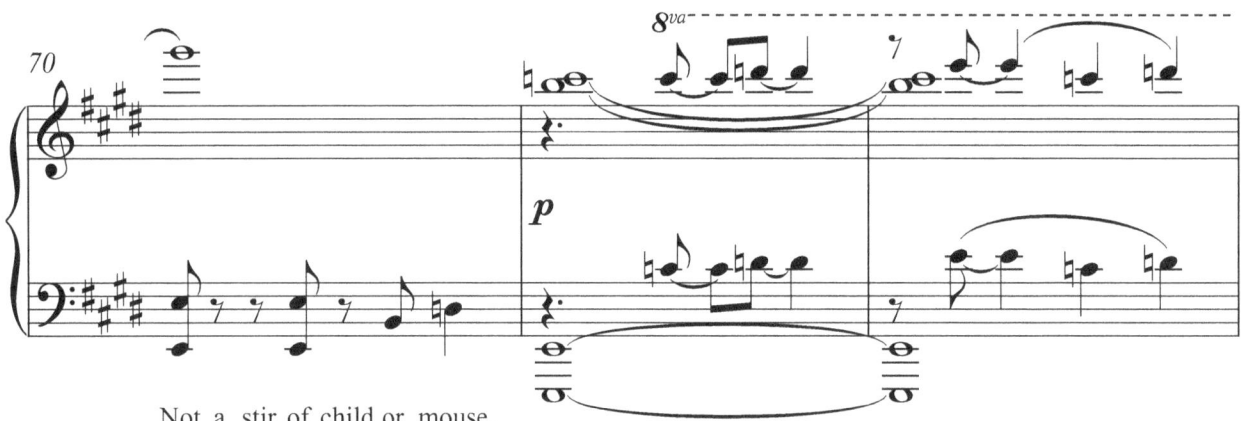

Not a stir of child or mouse,

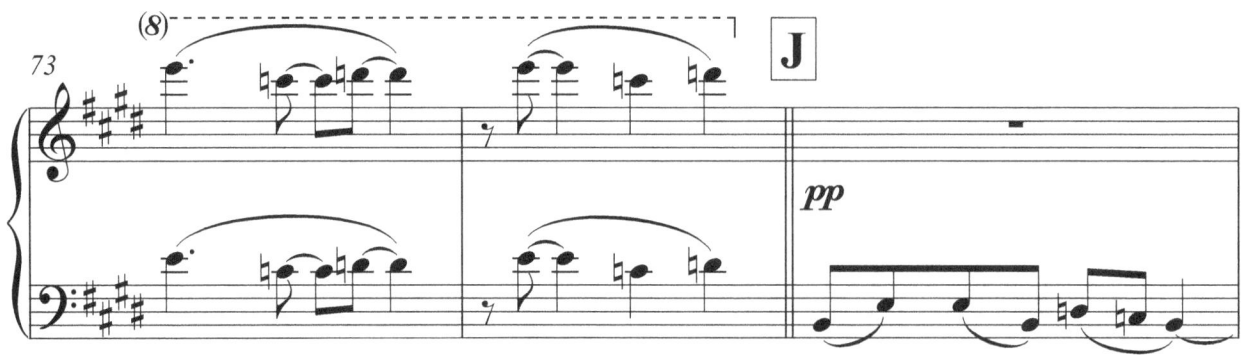

And when kindly falls the night,

In all the town no spark of light.

There I'll come when I'm a man With a camel caravan;

Light a fire in the gloom Of some dusty dining room;

64

See the pictures on the walls,

Heroes, fights and festivals; And in a corner find the

toys Of the old Egyptian boys.

Happy Thought

The world is so full of a number of things,
 I'm sure we should all be as happy as kings.

The Dumb Soldier

*From A Child's Garden of Verses Suite
for Piano and Reader*

Poem by Robert Louis Stevenson

Music by Rob Honey

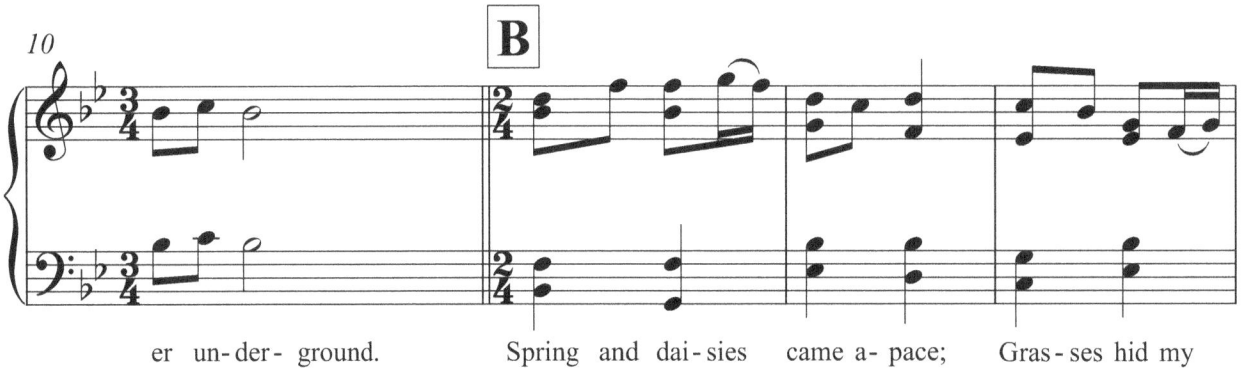
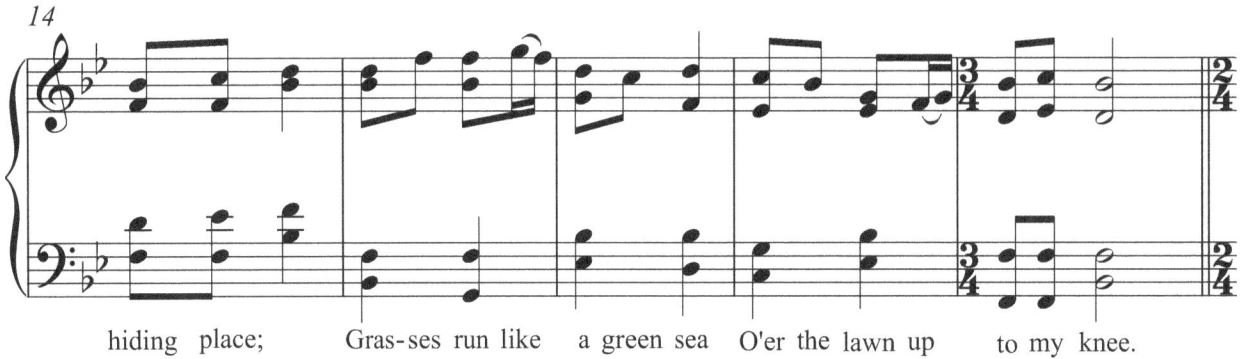

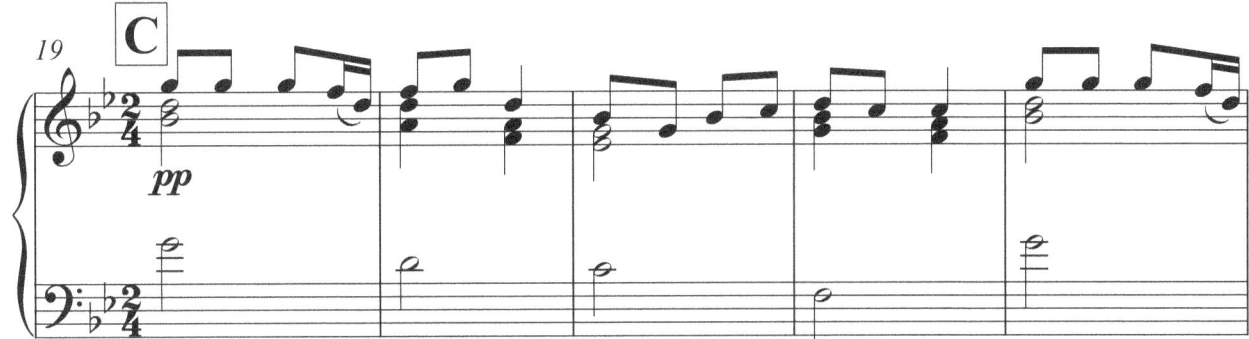
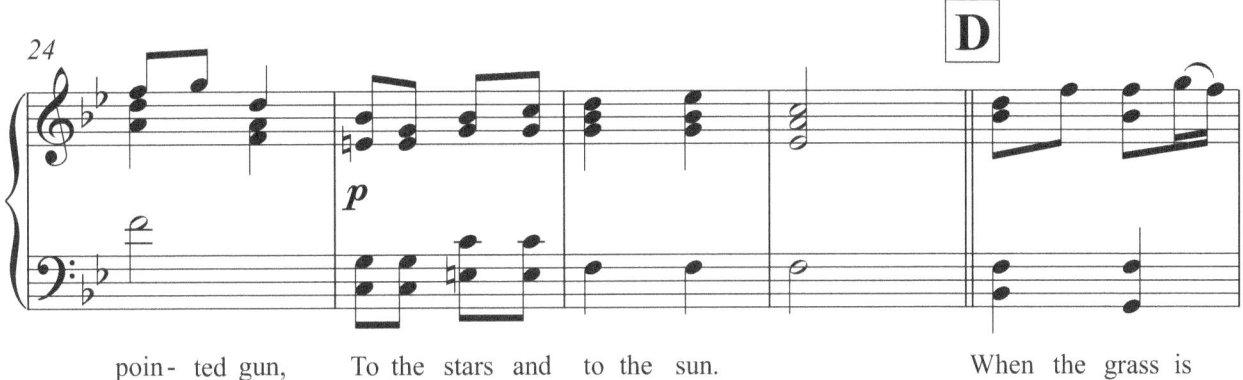

Foreign Lands

*From A Child's Garden of Verses Suite
for Piano and Reader*

Poem by Robert Louis Stevenson

Music by Rob Honey

Copelandesque ♩ = 82

Up into the cherry

tree

Who should climb but little me?

I held the trunk with both my hands

And looked abroad in foreign lands.

72

next door garden lie,

Adorned with flowers, before my eye

And many pleasant places more

That I had never seen before.

I saw the dimpling river pass

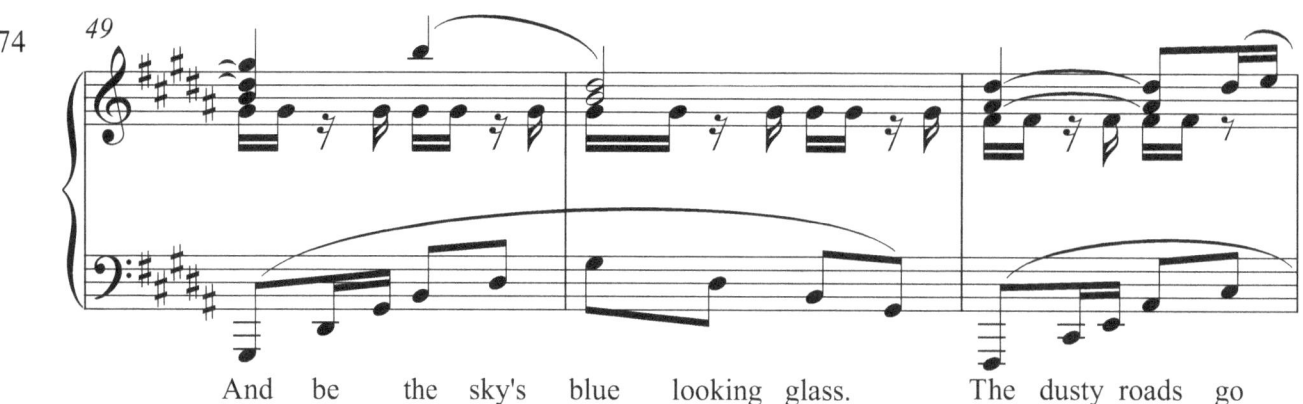

And be the sky's blue looking glass. The dusty roads go

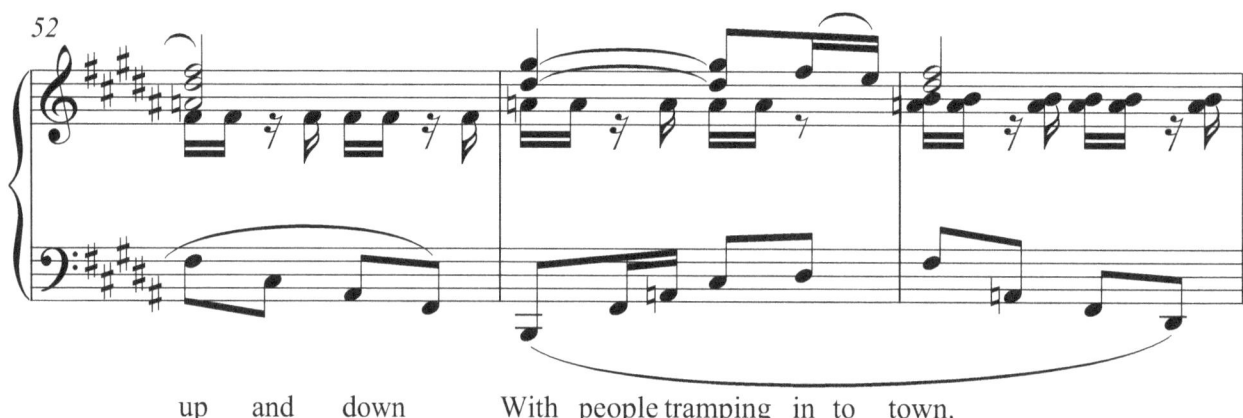

up and down With people tramping in to town.

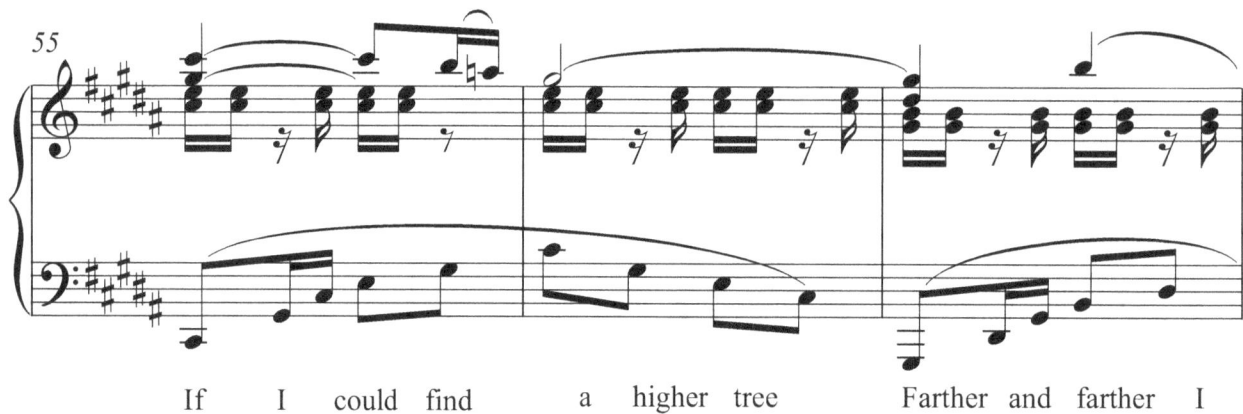

If I could find a higher tree Farther and farther I

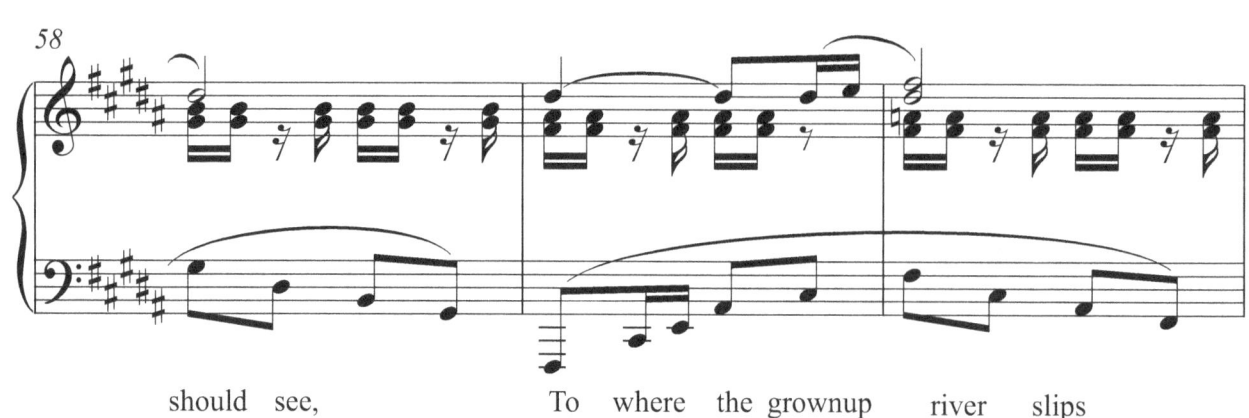

should see, To where the grownup river slips

Into the sea among the ships,

To where the roads on either hand

Lead onward into fairy

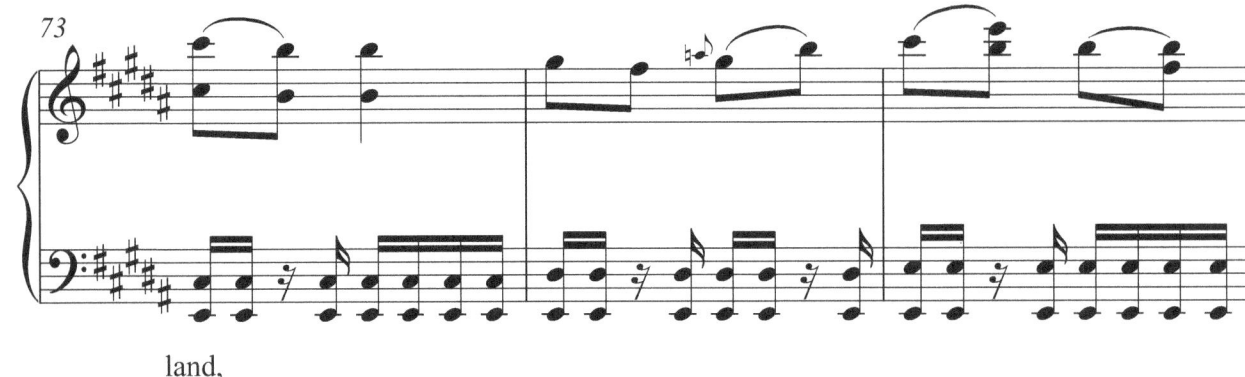

land,

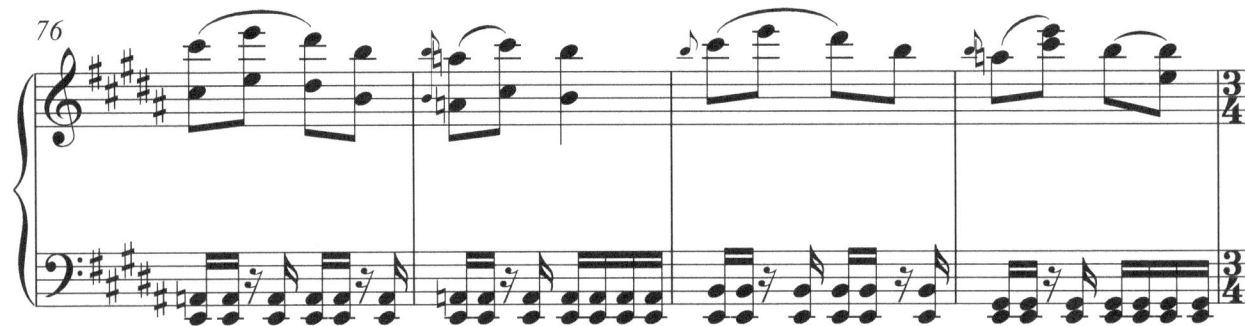

Where all the children dine at five,

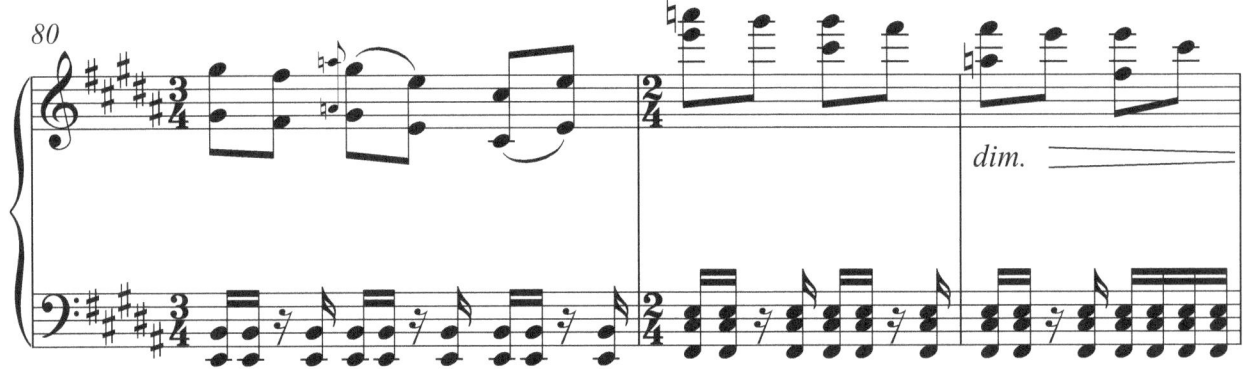

And all the playthings come alive.

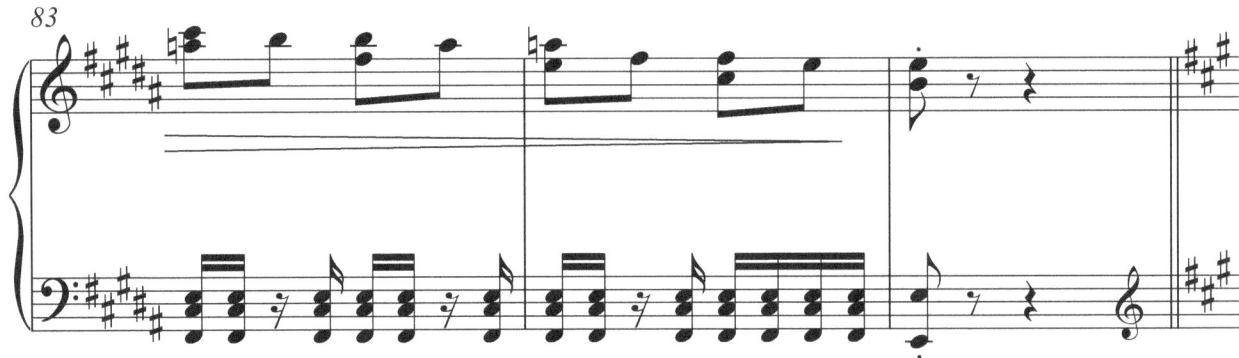

Auntie's Skirts

Whenever Auntie moves around,
Her dresses make a curious sound,
They trail behind her up the floor,
And trundle after through the door.

The Land of Nod

From A Child's Garden of Verses Suite for Piano and Reader

Poem by Robert Louis Stevenson

Music by Rob Honey

All alone beside the streams

And up the mountain-sides of dreams.

The strangest things are these for me,

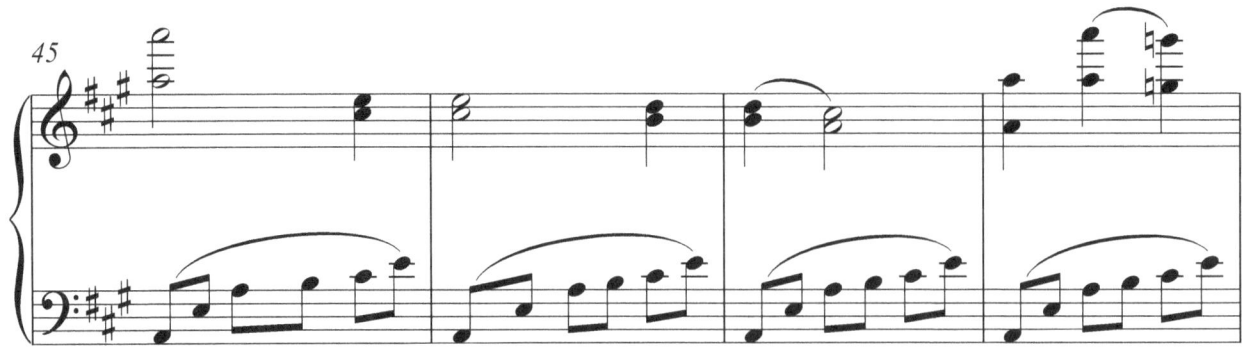

Both things to eat and things to see,

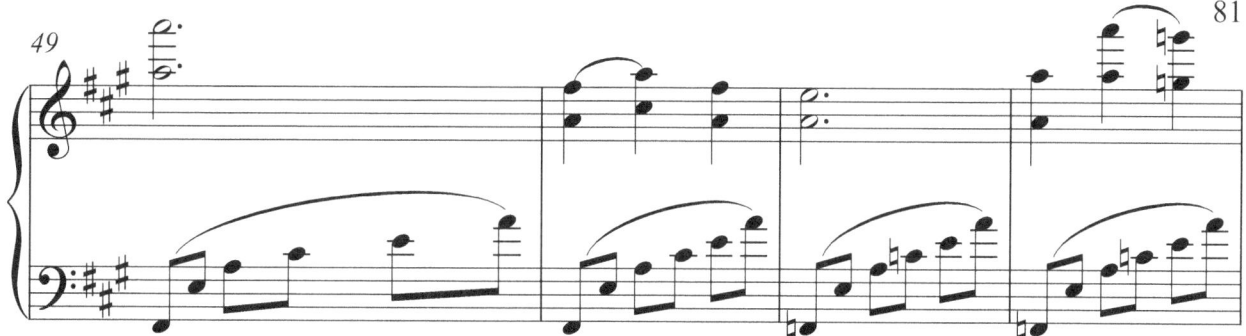

And many frightening sights abroad

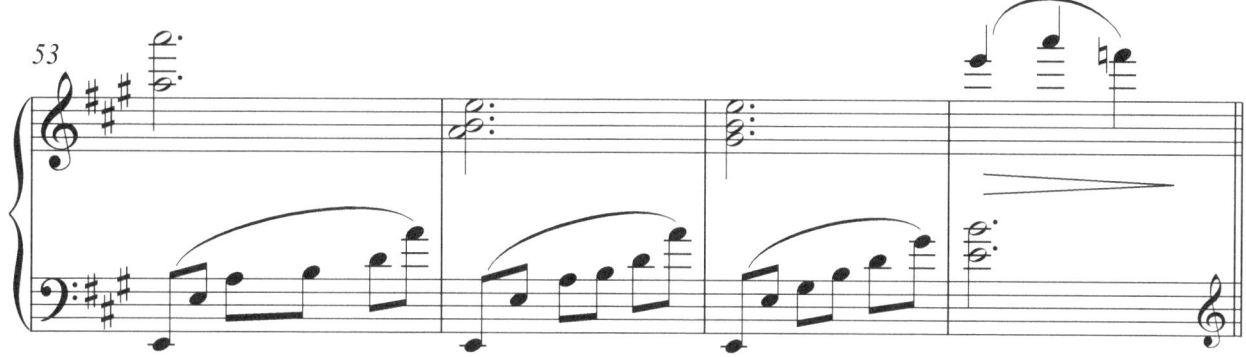

Till morning in the land of Nod.

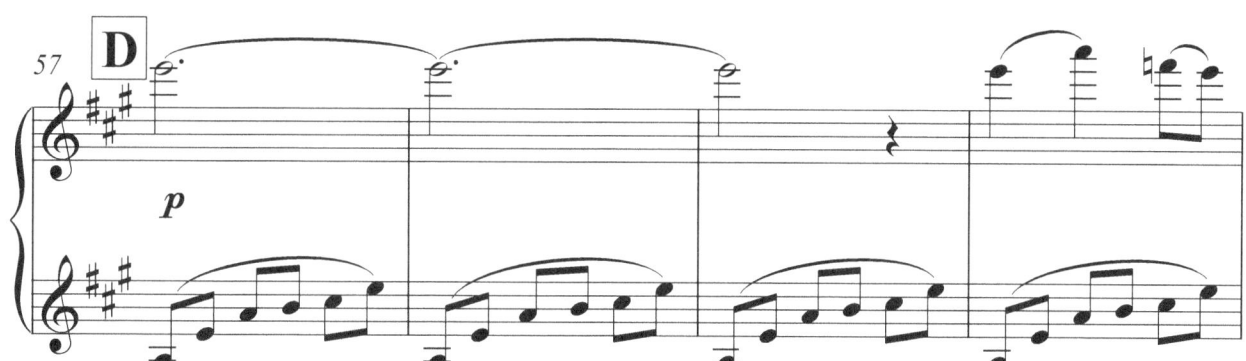

Try as I like to find the way,

I never can get back by day,

Nor can remember plain and clear

The curious music that I hear.

Looking Forward

When I am grown to man's estate
I shall be very proud and great,
And tell the other girls and boys
Not to meddle with my toys.

Garden Days

*From A Child's Garden of Verses Suite
for Piano and Reader*

Rob Honey

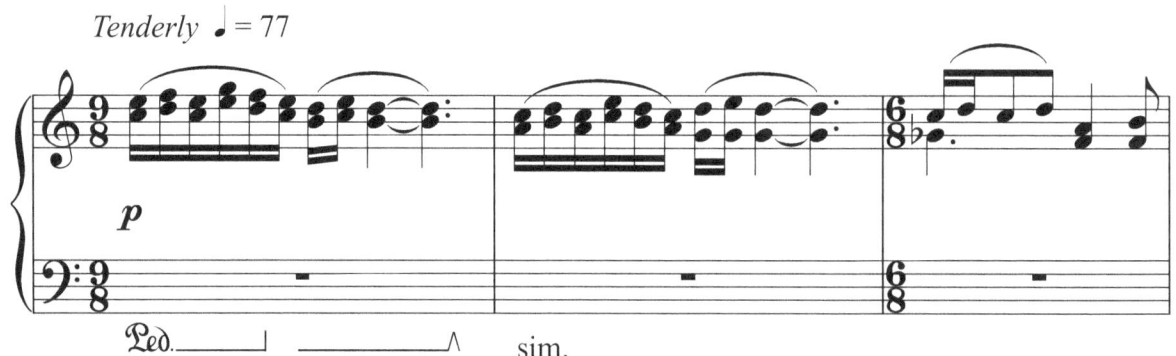
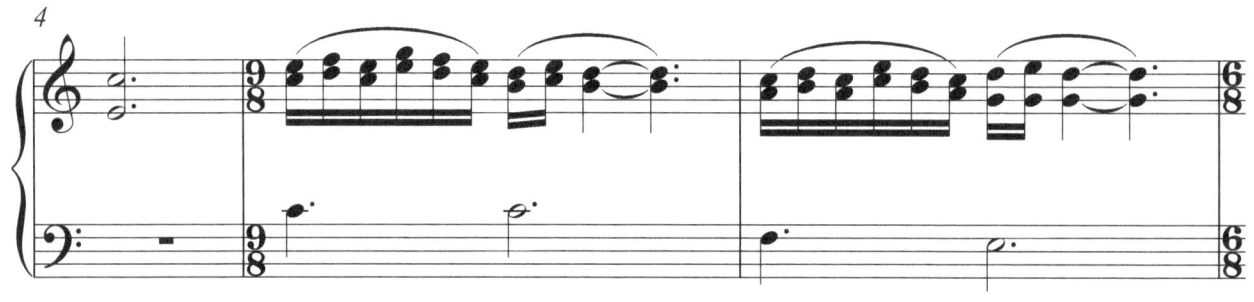
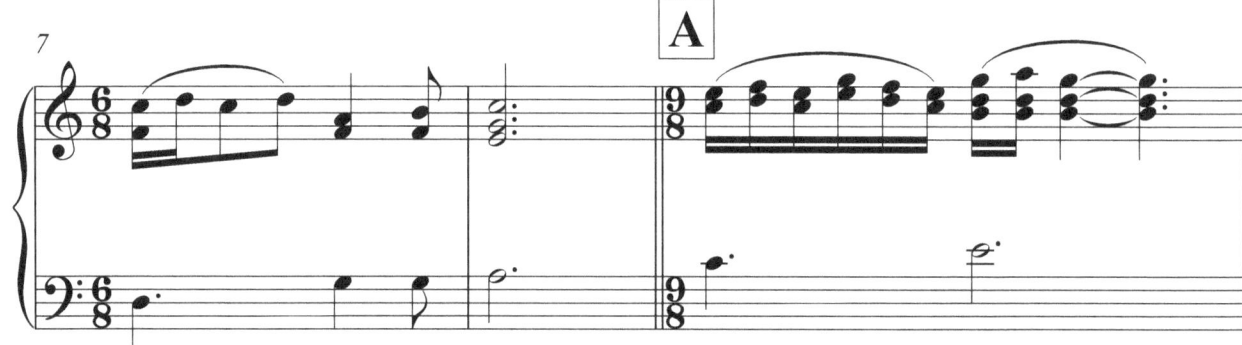
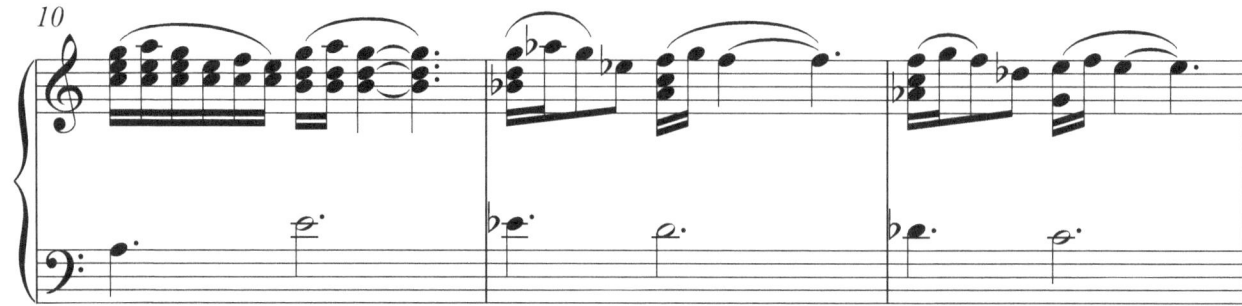

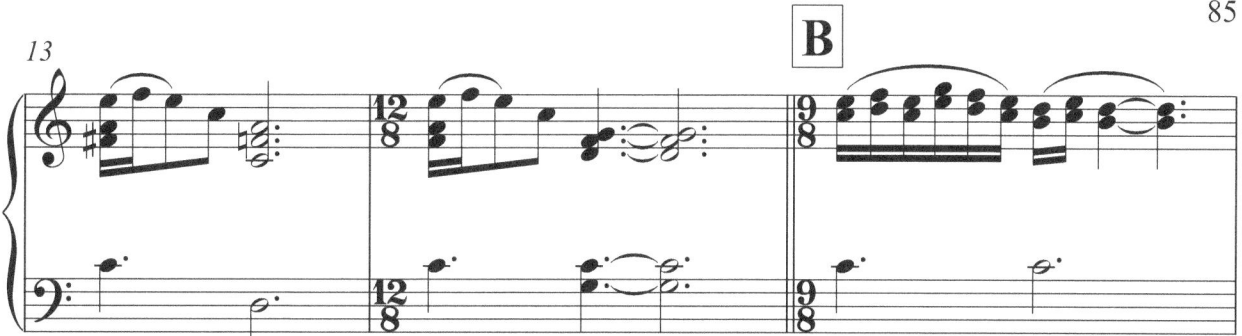
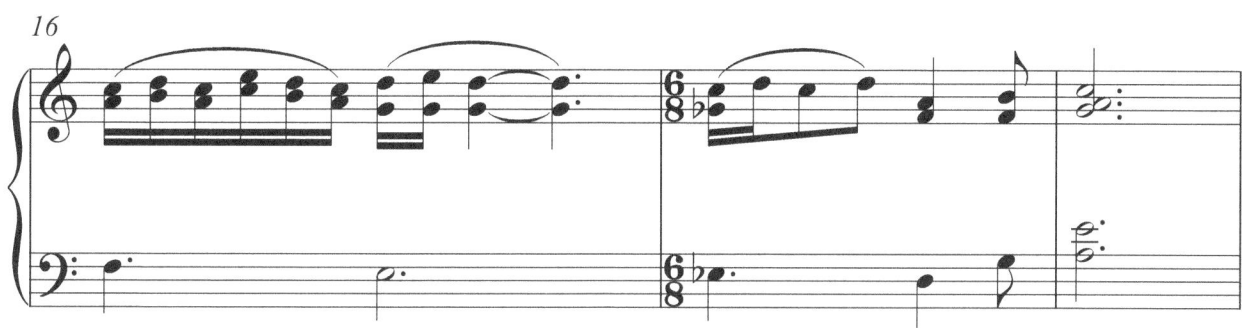
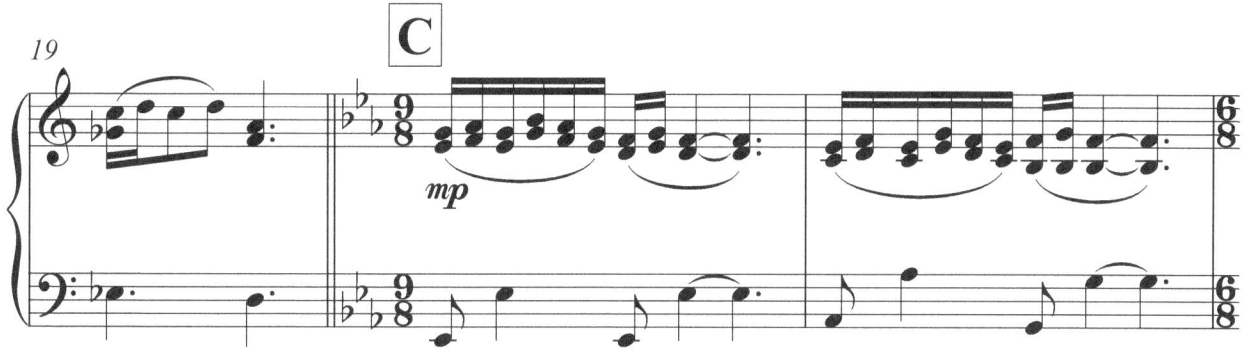
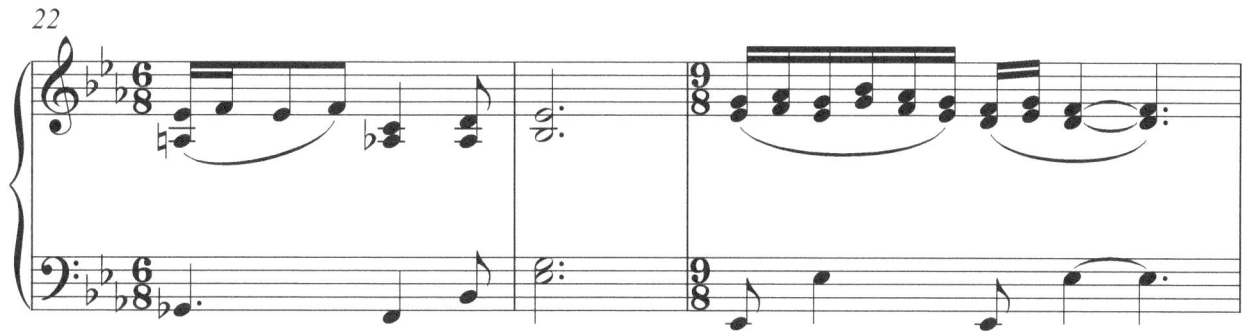

The Land of Story-Books

From A Child's Garden of Verses Suite for Piano and Reader

Poem by Robert Louis Stevenson

Music by Rob Honey

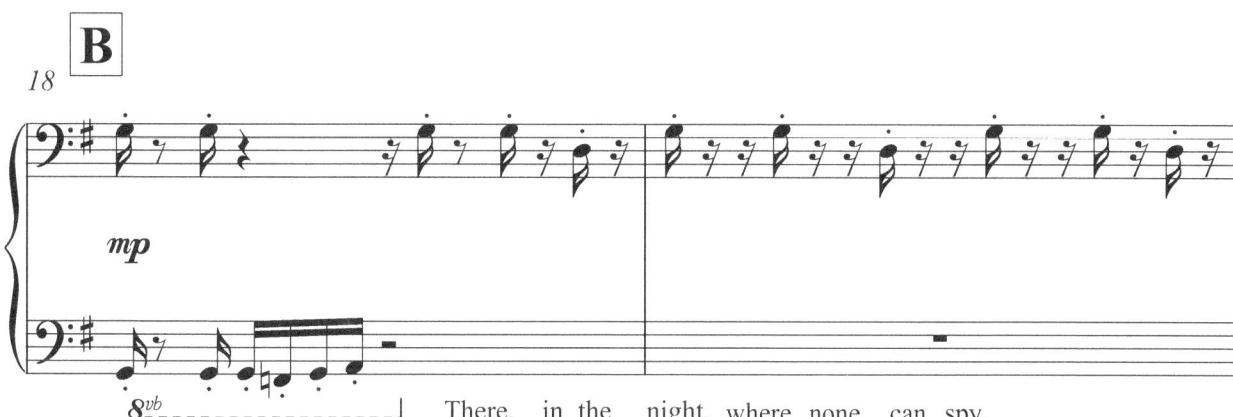

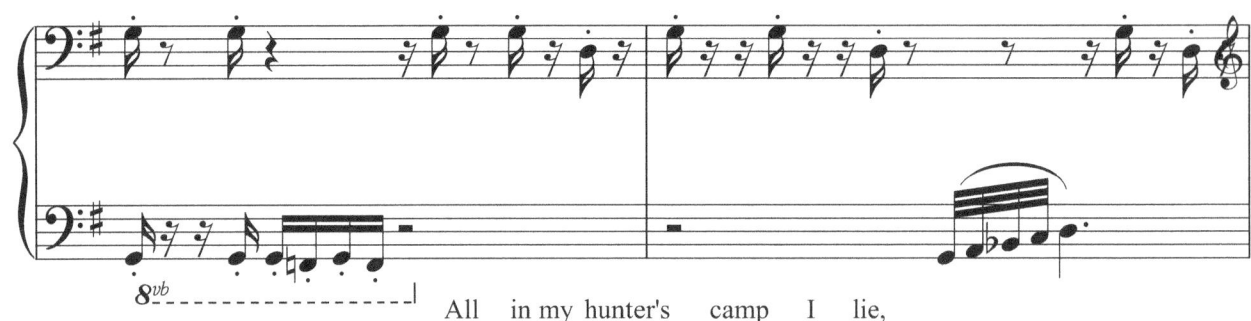
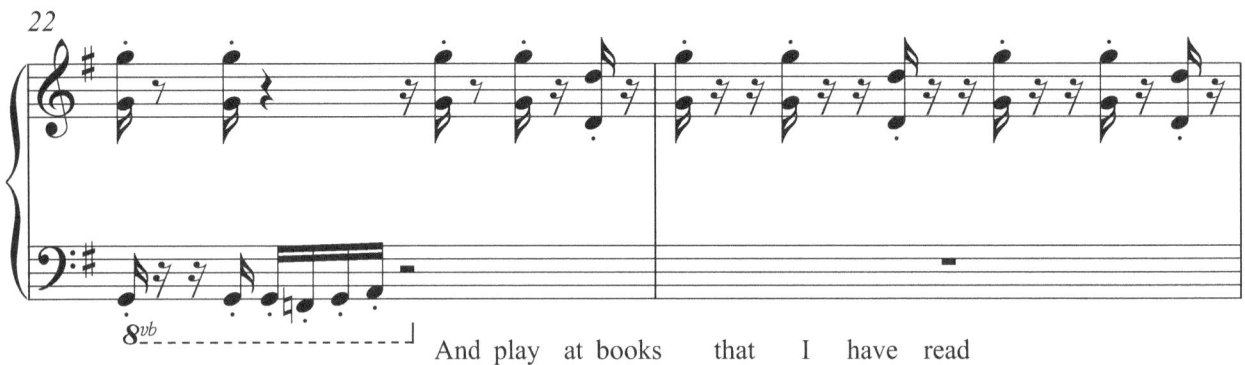
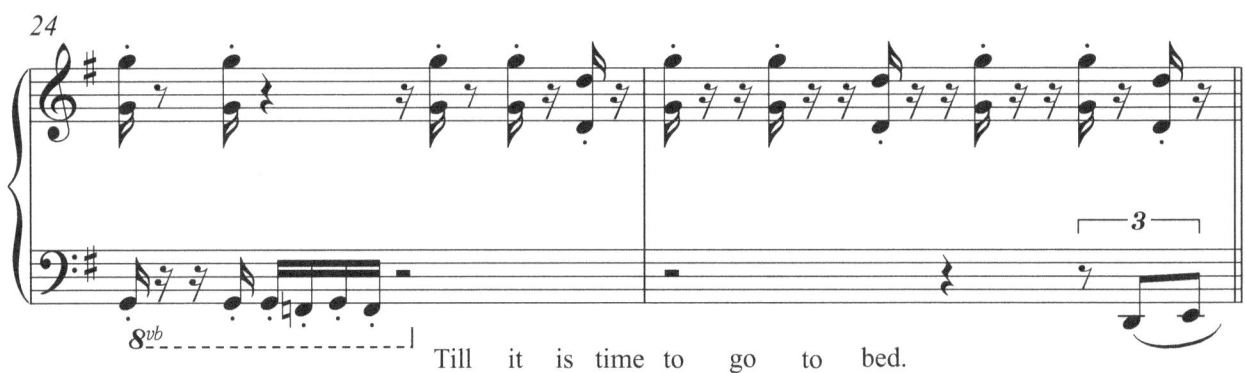
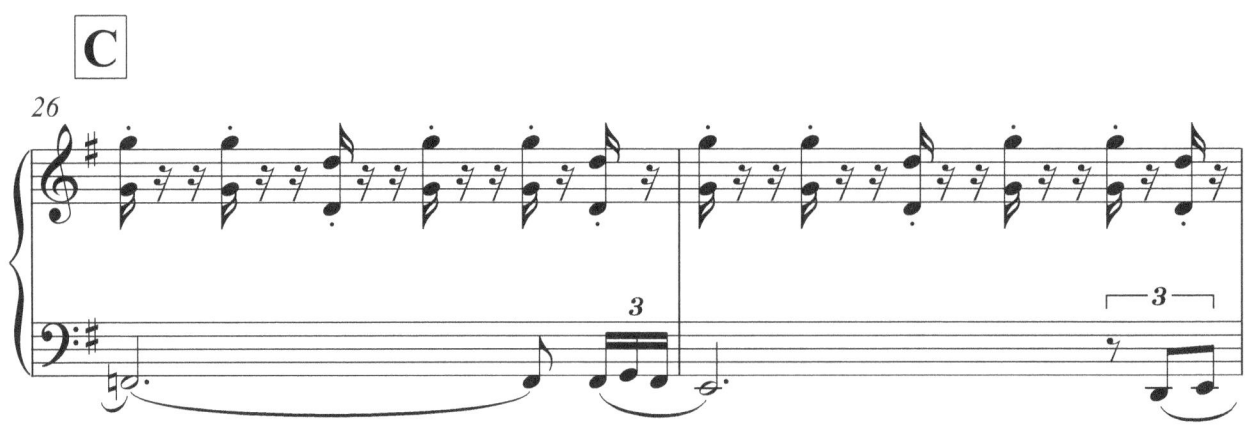

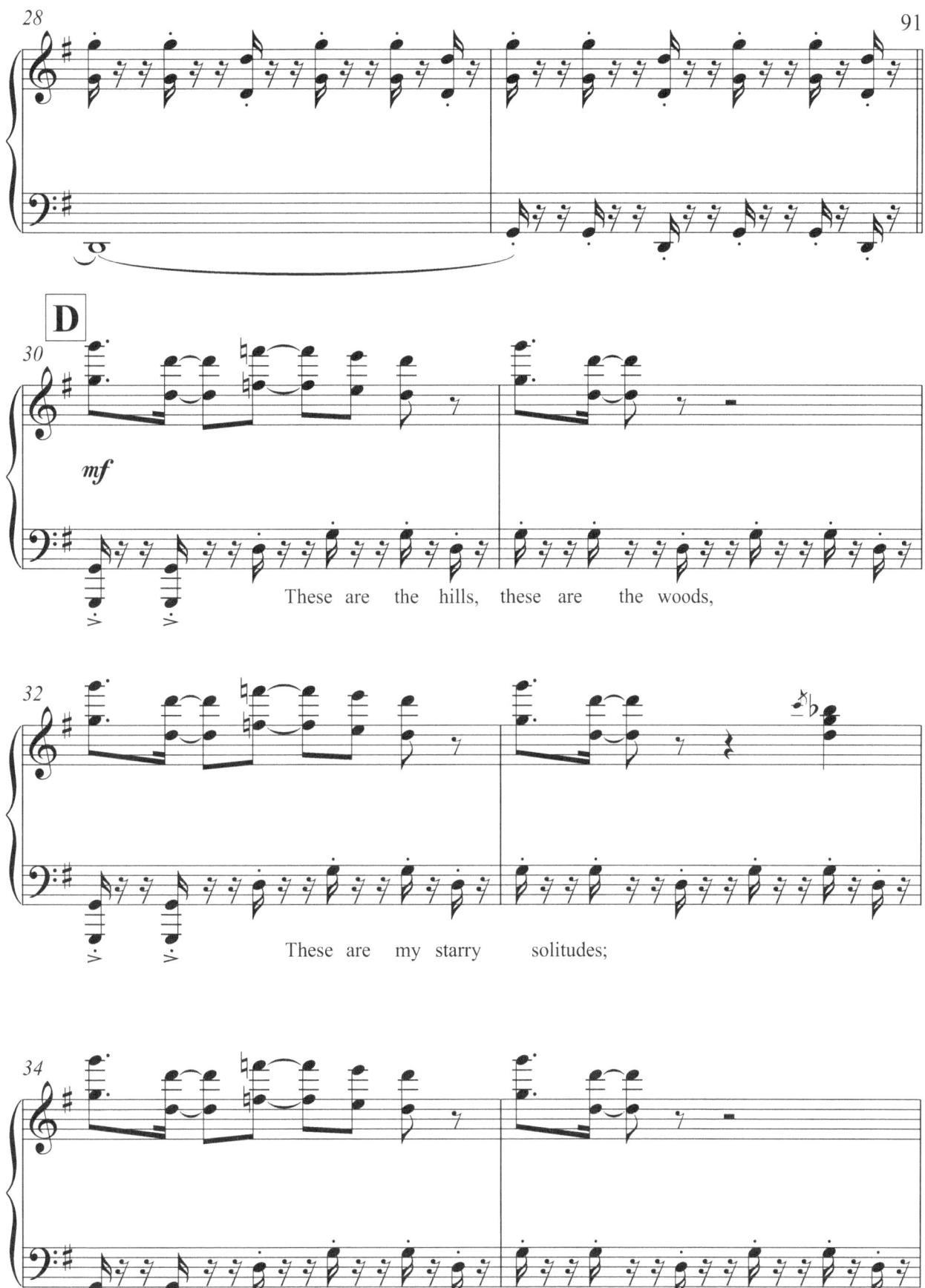

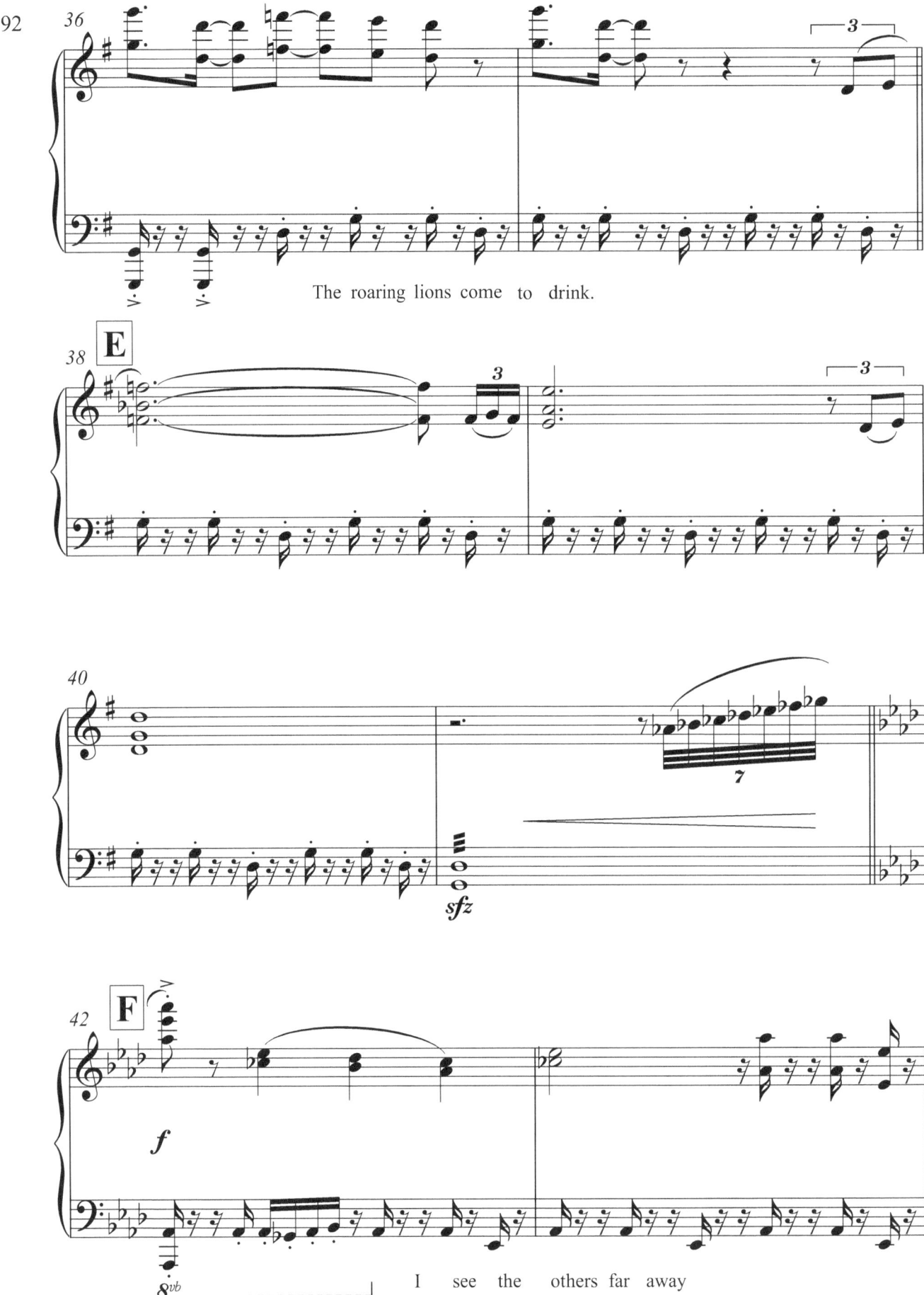

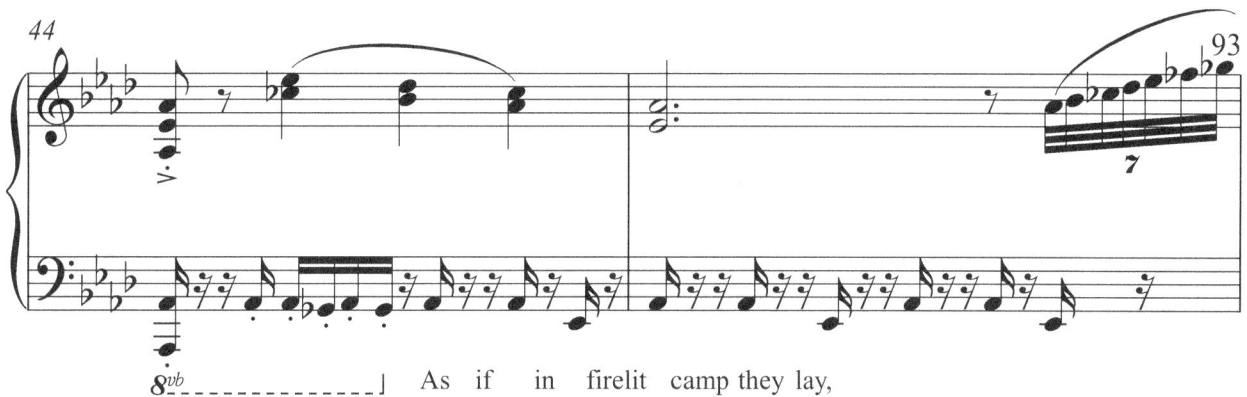

the sea, And go to bed with backward looks

At my dear land of Storybooks.

The Lamp Lighter

My tea is nearly ready and the sun has left the sky.
It's time to take the window to see Leerie going by;
For every night at teatime and before you take your seat,
With lantern and with ladder he comes posting up the street.

Now Tom would be a driver and Maria go to sea,
And my papa's a banker and as rich as he can be;
But I, when I am stronger and can choose what I'm to do,
O Leerie, I'll go round at night and light the lamps with you!

For we are very lucky, with a lamp before the door,
And Leerie stops to light it as he lights so many more;
And oh! before you hurry by with ladder and with light;
O Leerie, see a little child and nod to him to-night!

Block City

From A Child's Garden of Verses Suite for Piano and Reader

Poem by Robert Louis Stevenson

Music by Rob Honey

What are you able

to build with your blocks? Castles and palaces,

temples and docks.

Rain may keep raining, and others go roam,

But I can be happy

and building at home. Let the sofa be mountains.

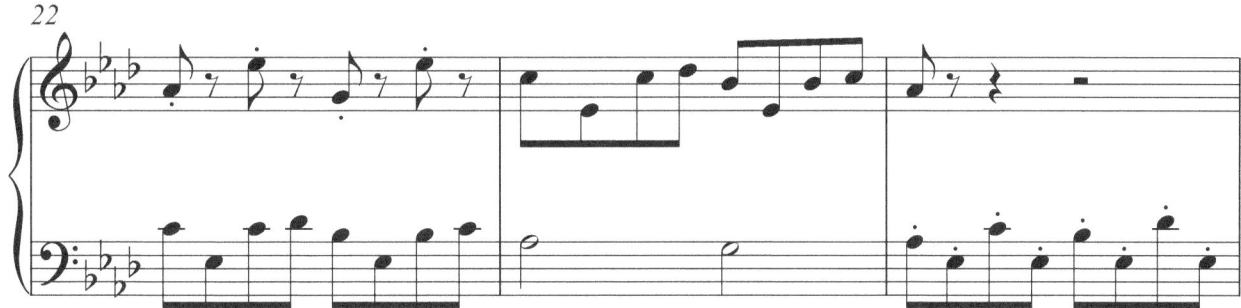

the carpet be sea,

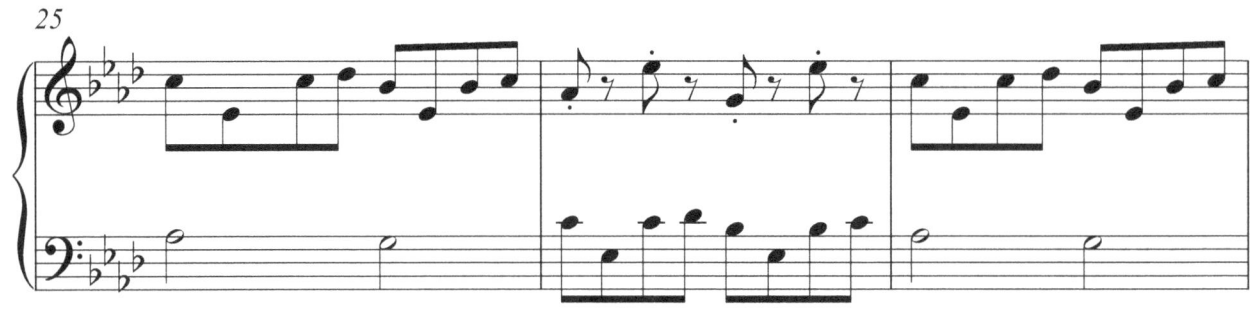

There I'll establish a city for me:

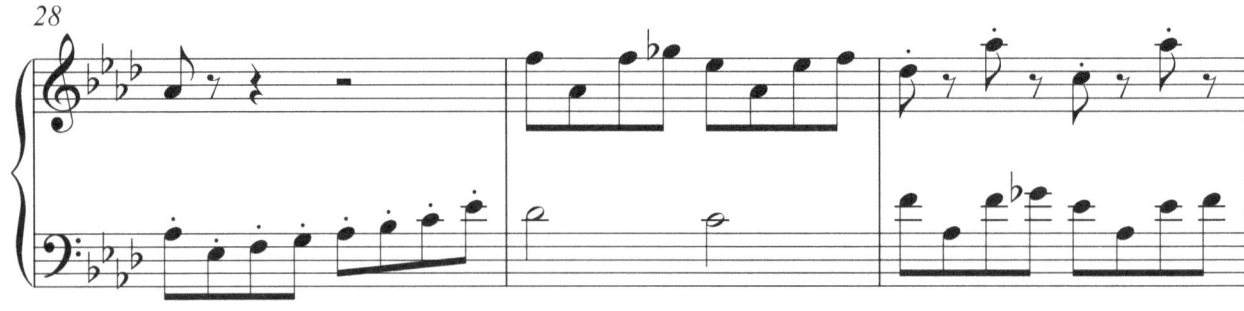

A kirk and a mill

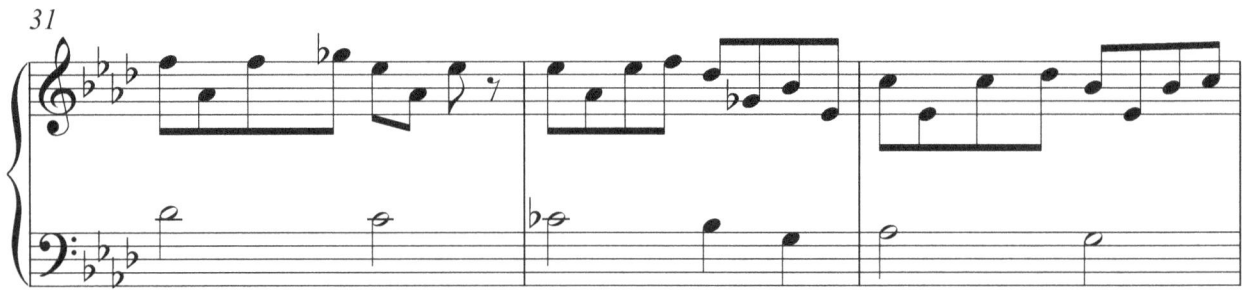

and a palace beside, And a harbour as well

where my vessels may ride.

Great is the palace with pillar and wall, A sort of a tower

on the top of it all, And steps coming down in an orderly way

To where my toy vessels lie safe in the bay.

This one is sailing and that one is moored:

100

Hark to the song

of the sailors aboard! And see, on the steps

of my palace, the kings

Coming and going with presents and things!

101

The kirk and the palace, the ships and the men,

And as long as I live

and where'er I may be, I'll always remember

my town by the sea.

Whole Duty of Children

A child should always say what's true
And speak when he is spoken to,
And behave mannerly at table;
At least as far as he is able

A Good Boy

From A Child's Garden of Verses Suite
for Piano and Reader

Poem by Robert Louis Stevenson

Music by Rob Honey

I woke before the morning, I was happy all the day,

I never said an ugly word, but smiled and stuck to play.

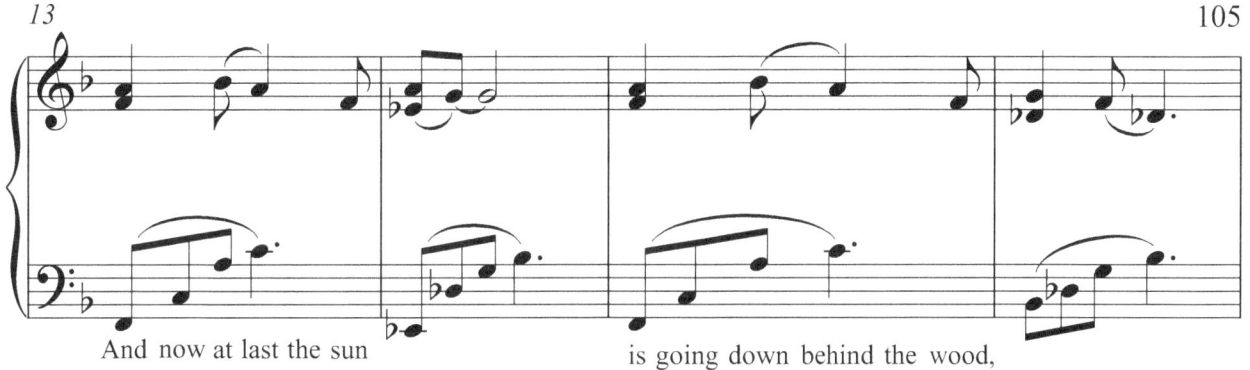

And now at last the sun is going down behind the wood,

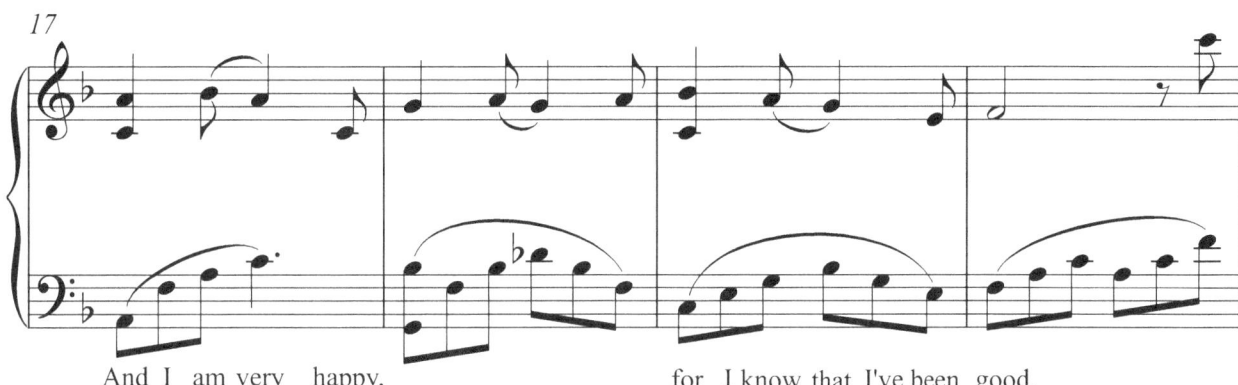

And I am very happy, for I know that I've been good.

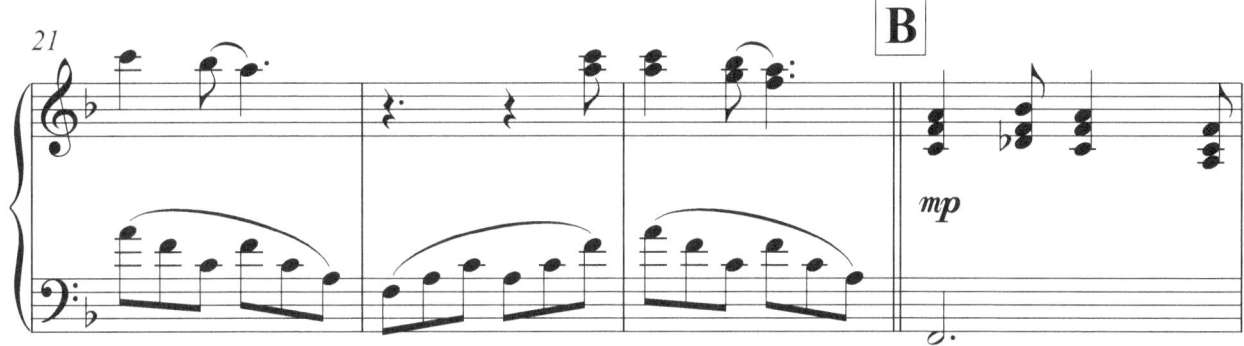

My bed is waiting cool and

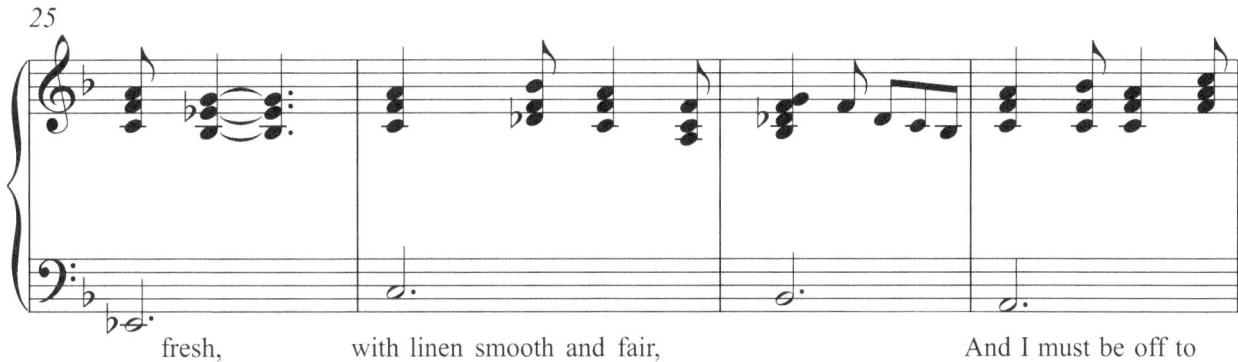

fresh, with linen smooth and fair, And I must be off to

And hear the thrushes singing　　　　　　in the lilacs round the lawn.

Good and Bad Children

*From A Child's Garden of Verses Suite
for Piano and Reader*

Poem by Robert Louis Stevenson

Music by Rob Honey

Children, you are very little, And your bones are very brittle;

If you would grow great and stately, You must try to walk sedately.

You must still be bright and quiet, And content with simple diet;

And remain, through all bewild'ring

Innocent and honest children. Happy hearts and happy faces,

Happy play in grassy places

That was how in ancient ages, Children grew to kings and sages.

But the unkind and the unruly,

And the sort who eat unduly, They must never hope for glory

Theirs is quite a different story!

Cruel children, crying babies, All grow up as geese and

gabies, Hated, as their age increases,

By their nephews and their nieces.

The Land of Counterpane

From A Child's Garden of Verses Suite for Piano and Reader

Poem by Robert Louis Stevenson

Music by Rob Honey

When I was sick and lay a-bed,

I had two pillows at my head, And all my toys beside me lay,

To keep me happy all the day. And sometimes for an hour or so

I watched my leaden soldiers go,

With different uniforms and drills, Among the bed clothes, through the hills;

And sometimes sent my ships in fleets

All up and down among the sheets; Or brought my trees and houses out,

And planted cities all about. I was the giant great and still

That sits upon the pillow hill, And sees before him, dale and plain,

The pleasant land of counterpane.

Bed in Summer

In winter I get up at night
And dress by yellow candle-light.
In summer quite the other way,
I have to go to bed by day.

I have to go to bed and see
The birds still hopping on the tree,
Or hear the grown-up people's feet
Still going past me in the street.

And does it not seem hard to you,
When all the sky is clear and blue,
And I should like so much to play,
To have to go to bed by day?

116

Marching Song

From A Child's Garden of Verses Suite
for Piano and Reader

Poem by Robert Louis Stevenson

Music by Rob Honey

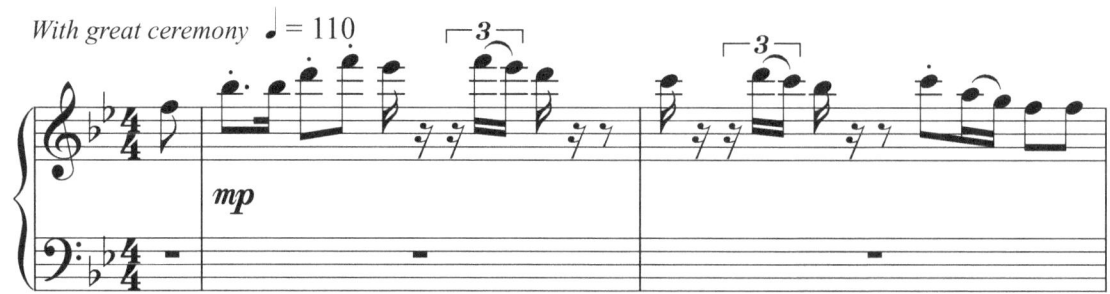
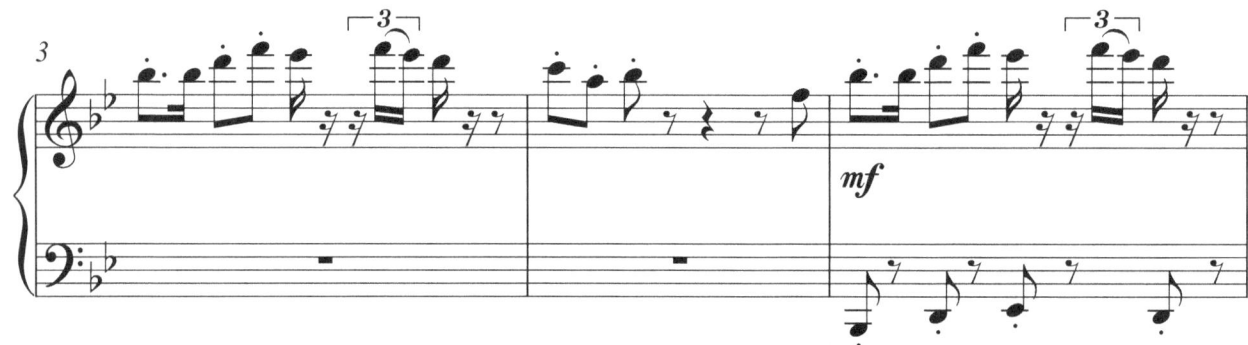
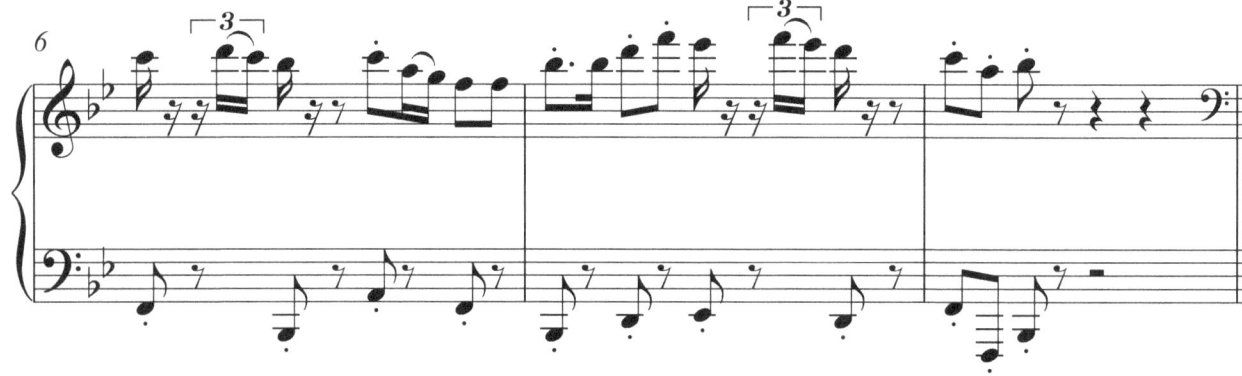
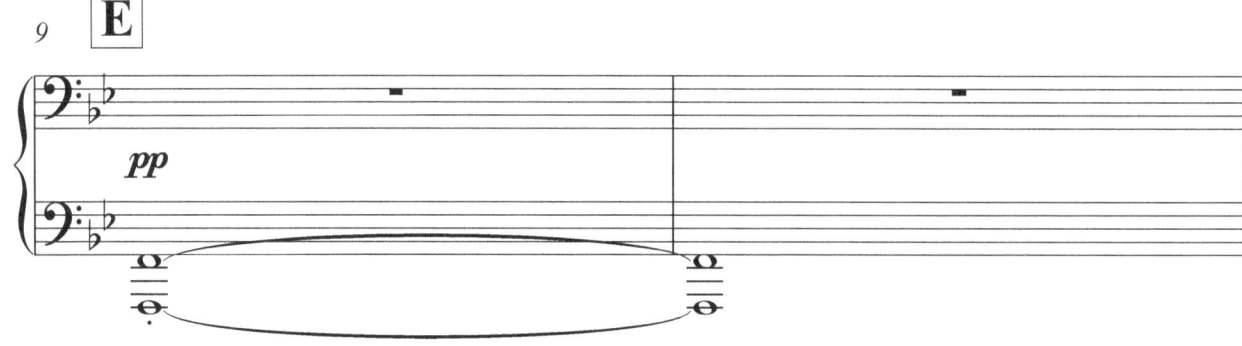

Bring the comb and play up - on it! March - ing, here we come!

Wil - lie cocks his high-land bon - net, John - nie beats the drum.

Ma - ry Jane com - mands the par - ty,

Pe - ter leads the rear; Feet in time, a - lert and hear - ty, Each a Gre - na - di - er!

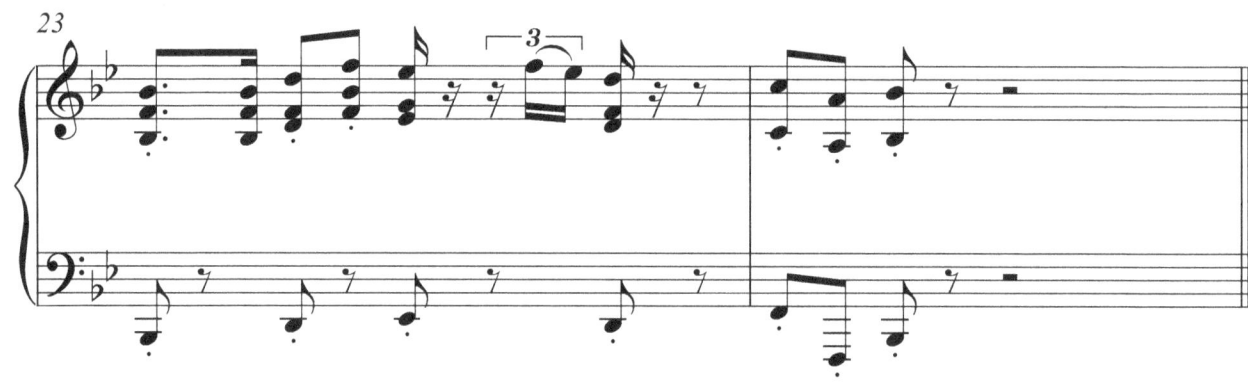
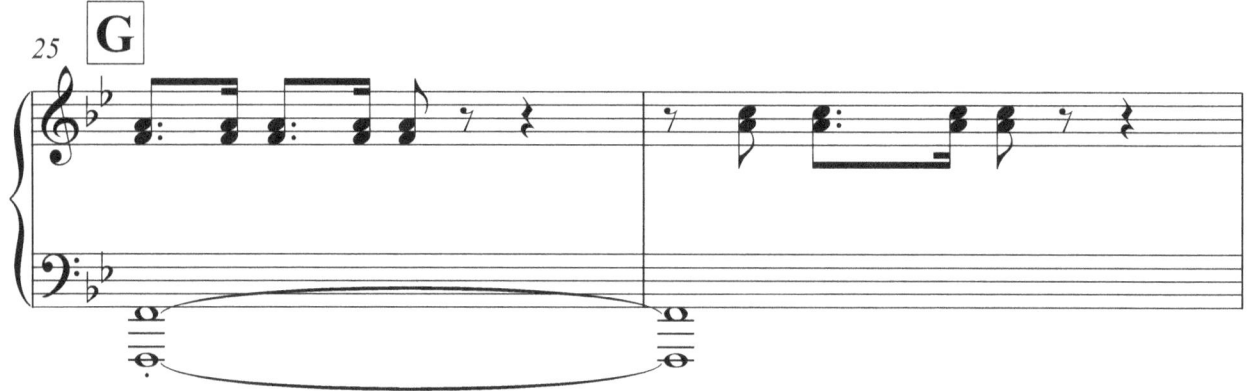

All in the most mar - tial man - ner March - ing double - quick;

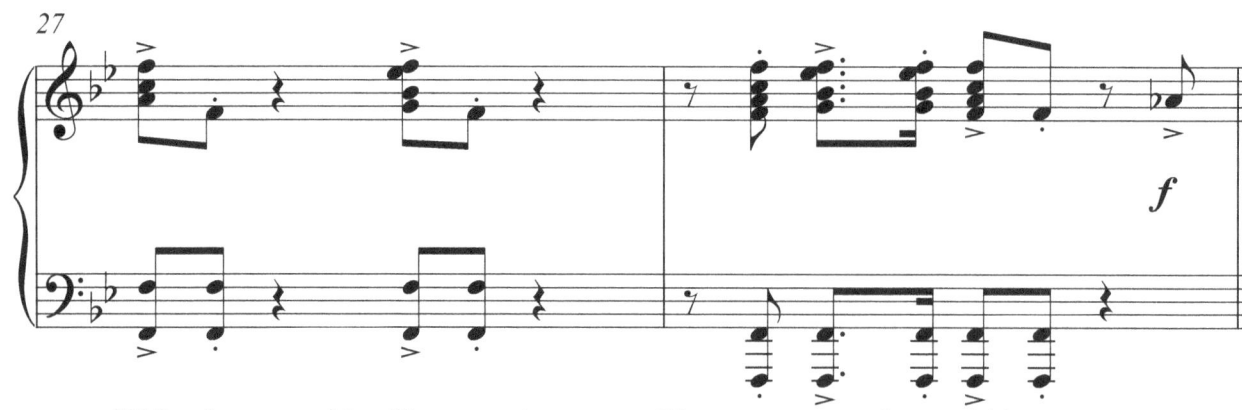

While the nap - kin, like a ban - ner, Waves up - on the stick!

119

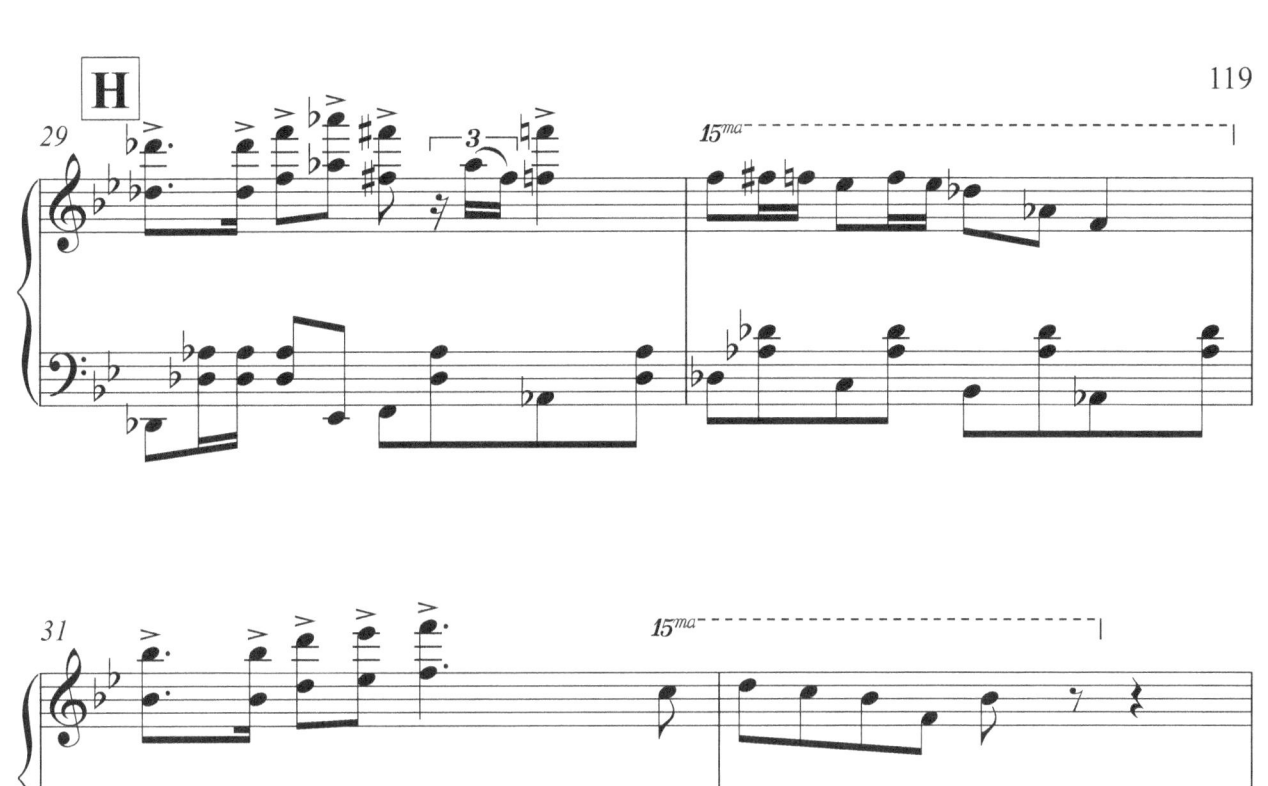

Here's e-nough of fame and pil-lage, Great com-man-der Jane!

Now that we've been round the vil-lage, Let's go home a-gain.

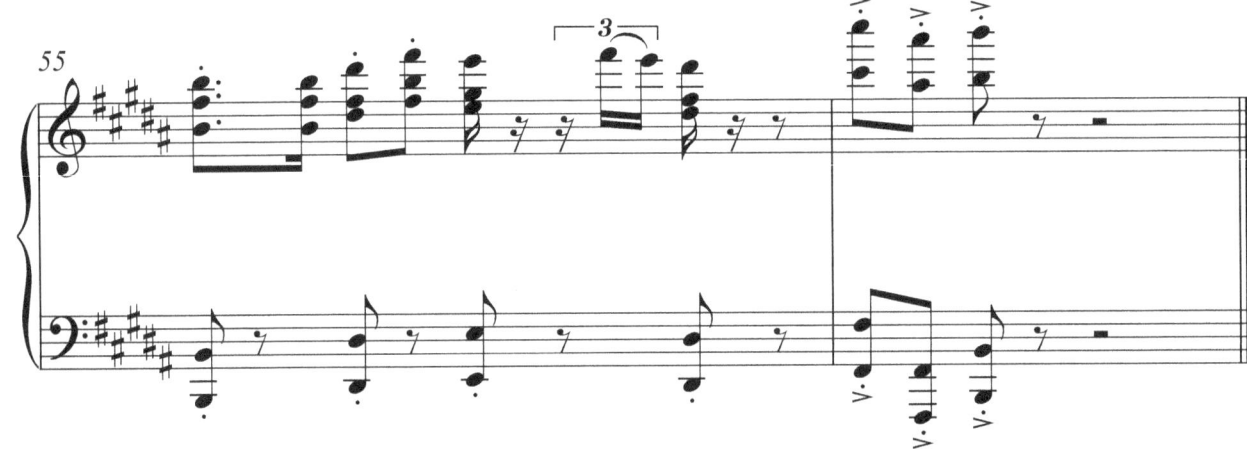